Detailed Mandala Coloring Journal

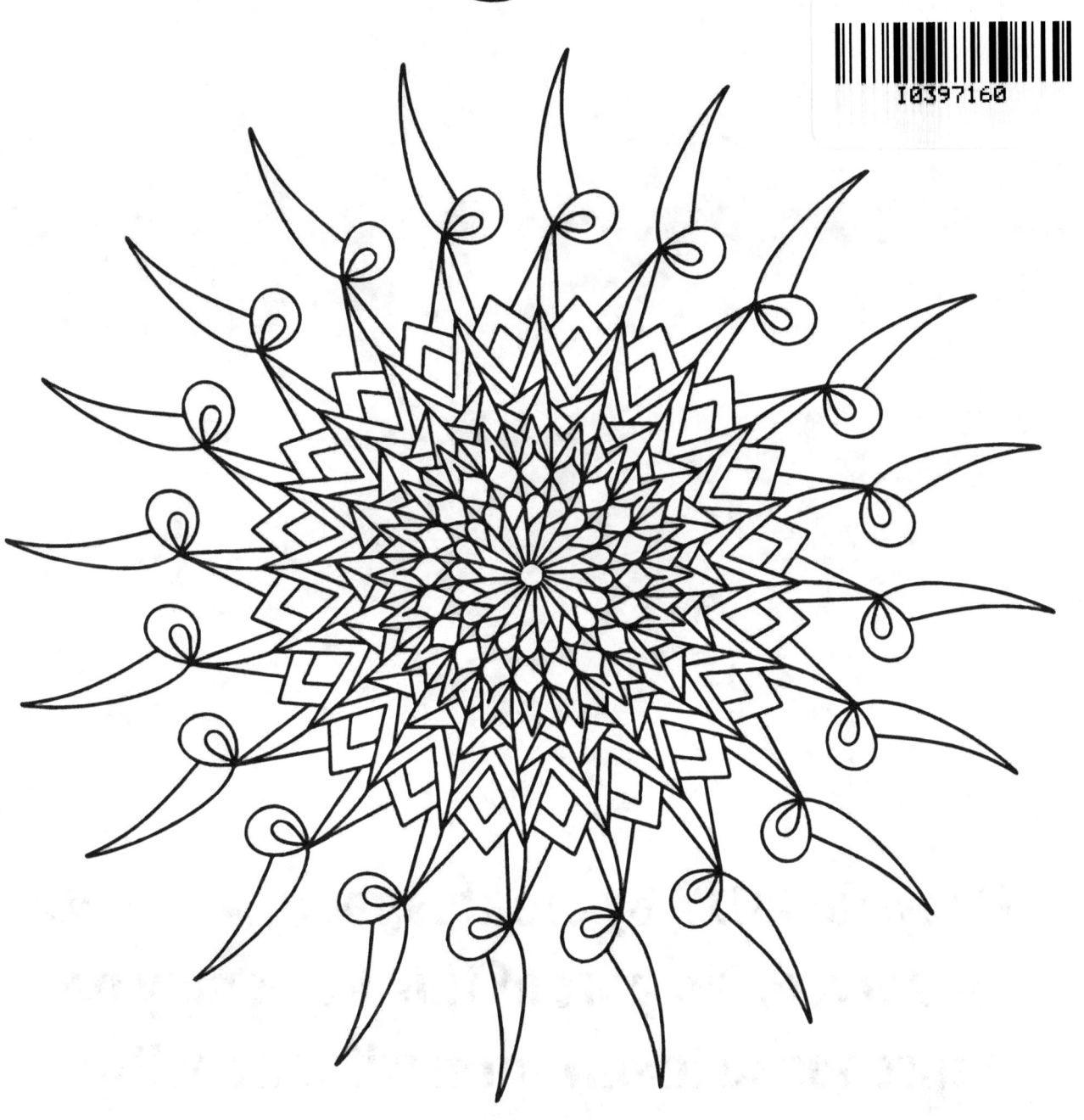

Morgan Imhoff

Copyrite 2017 by createspace. All rights reserved. No part of this book may be reproduced in any form without written concent
ISBN-13: 978-1545271964

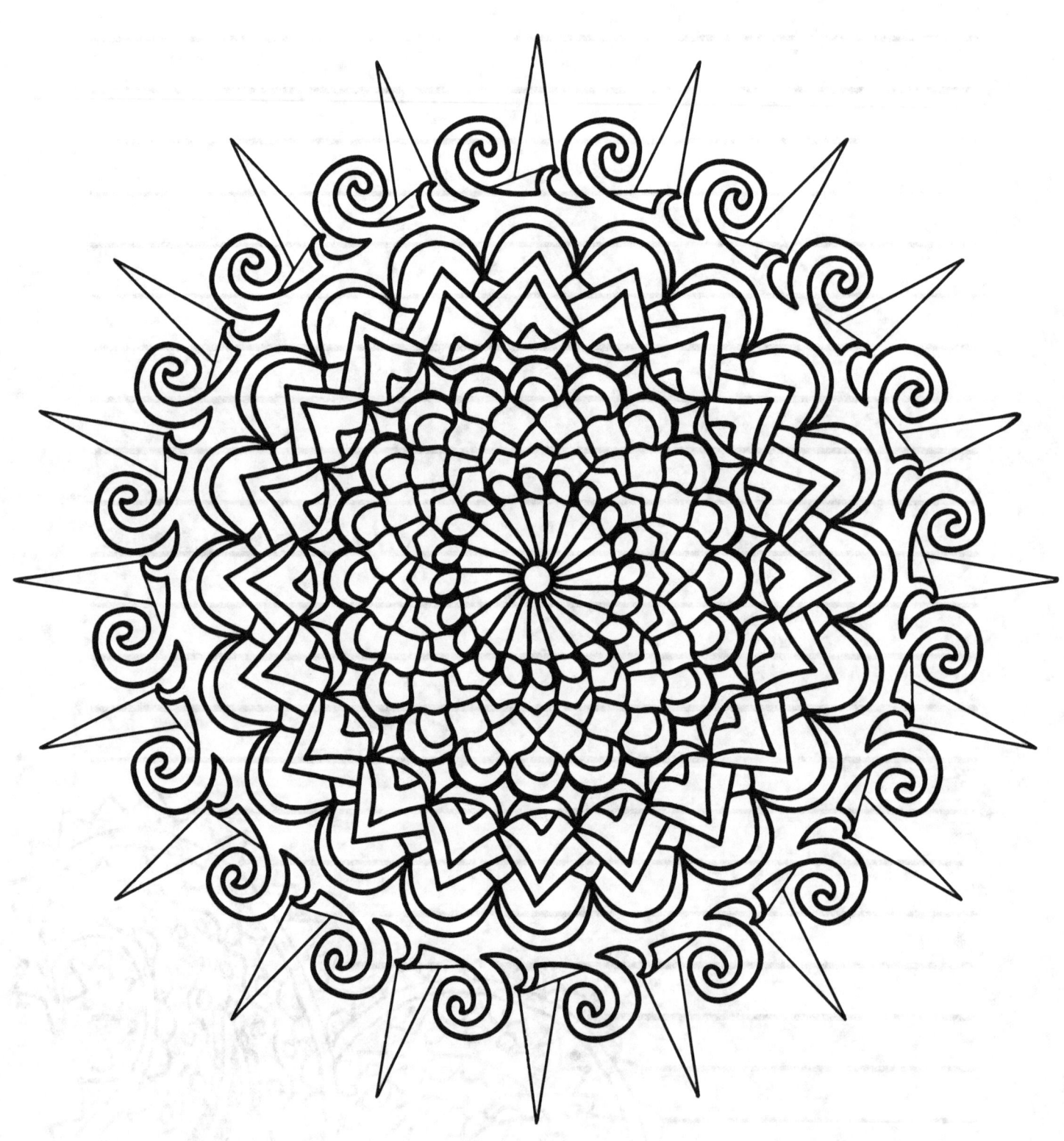

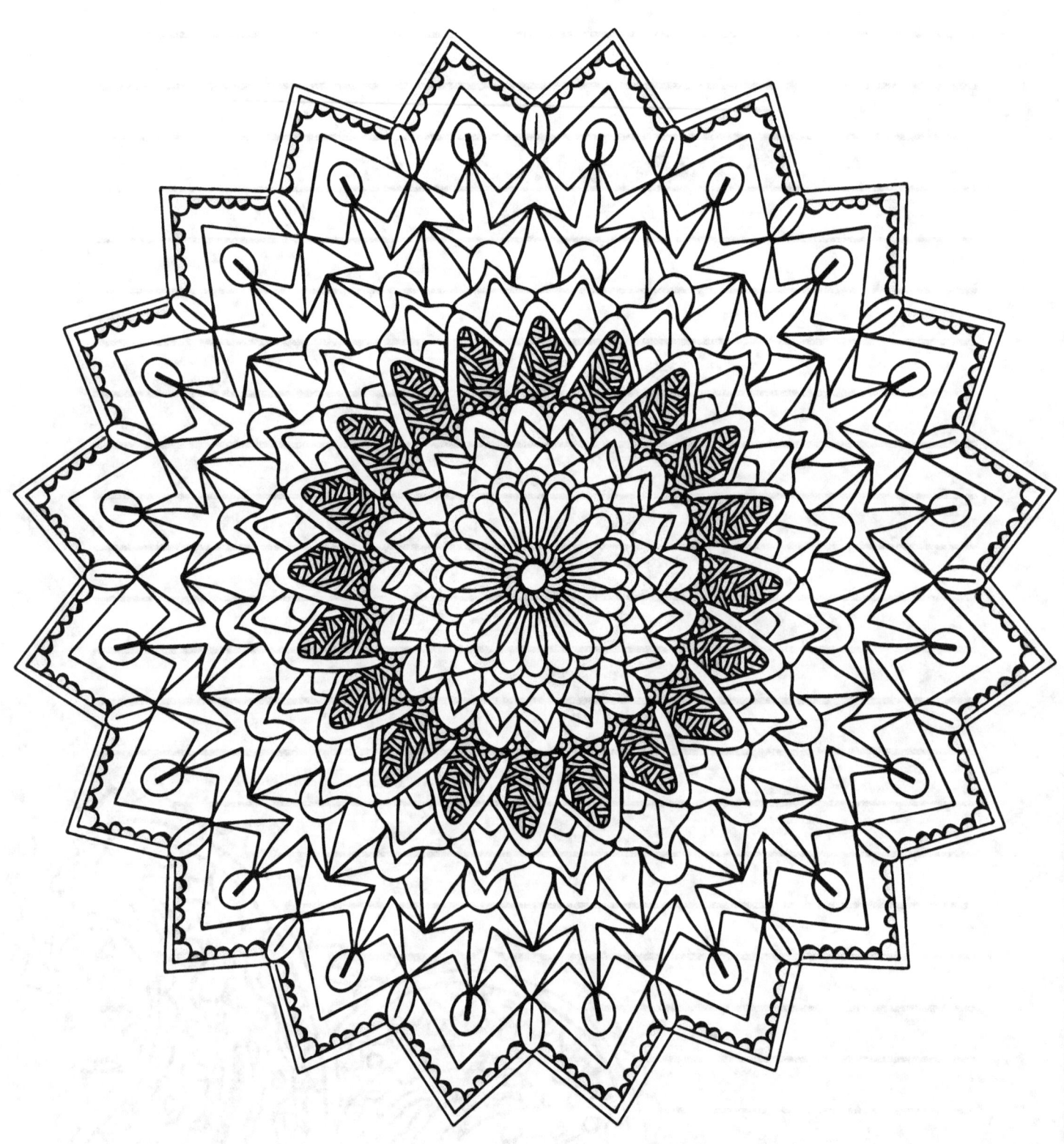

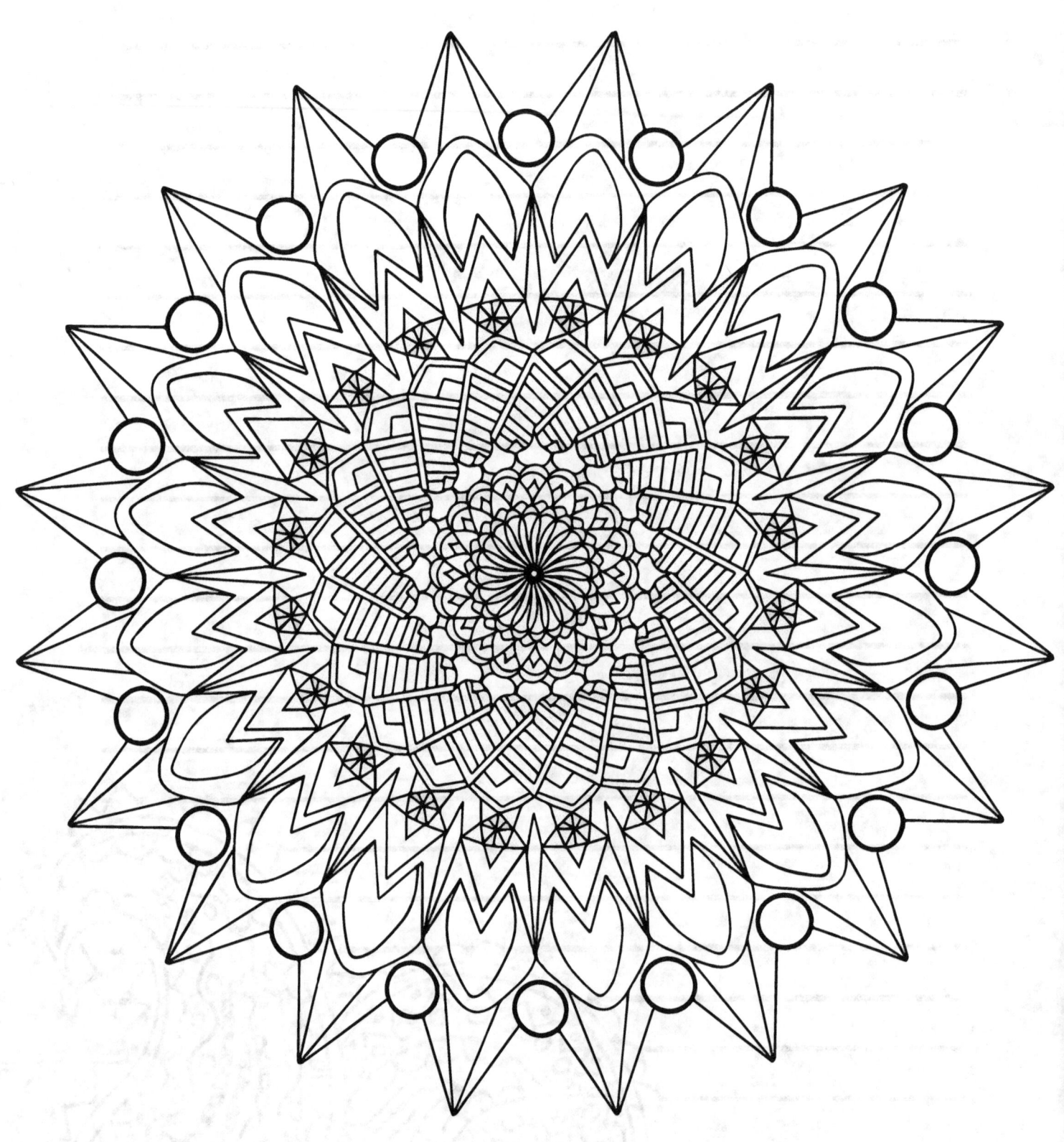

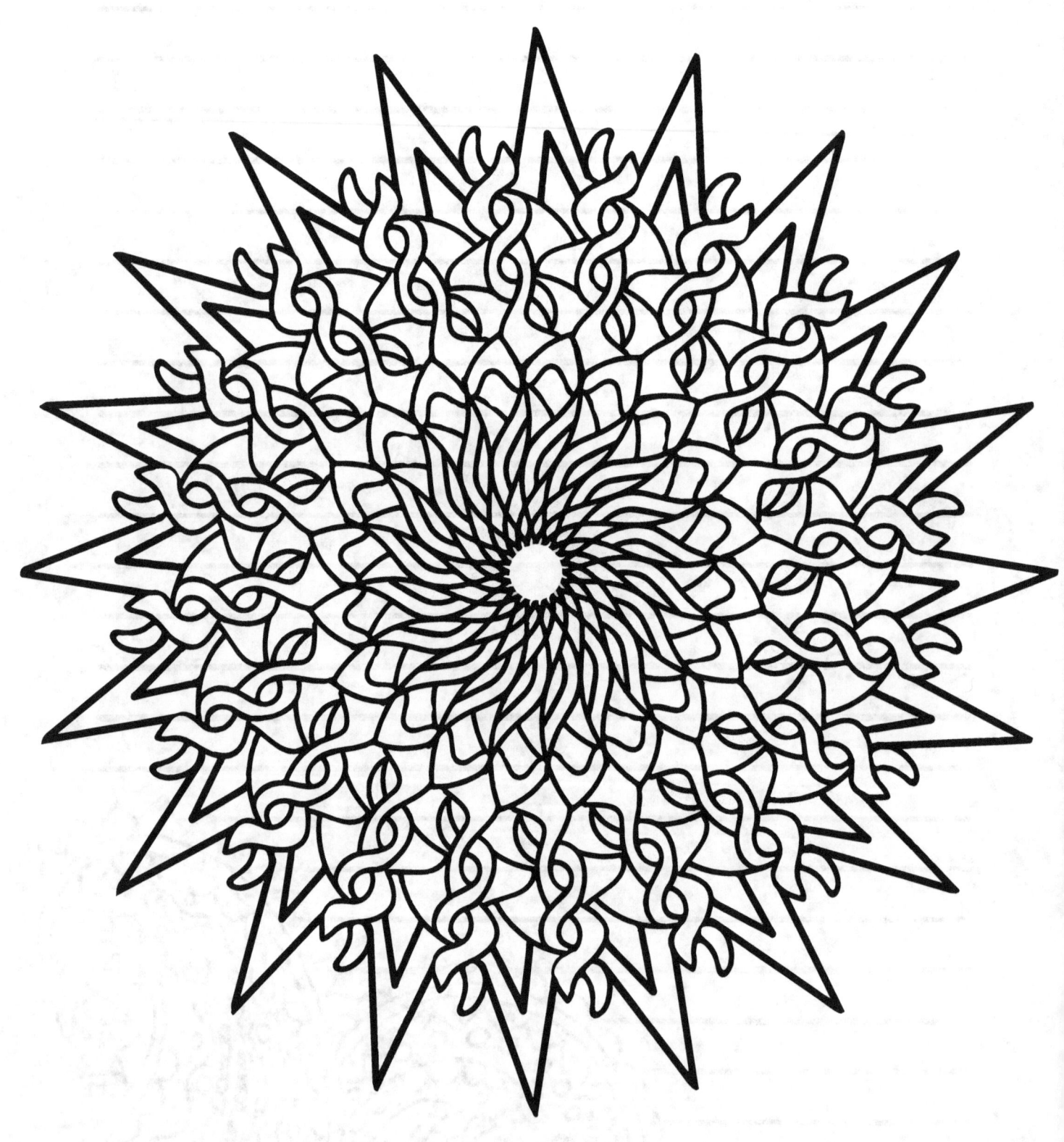

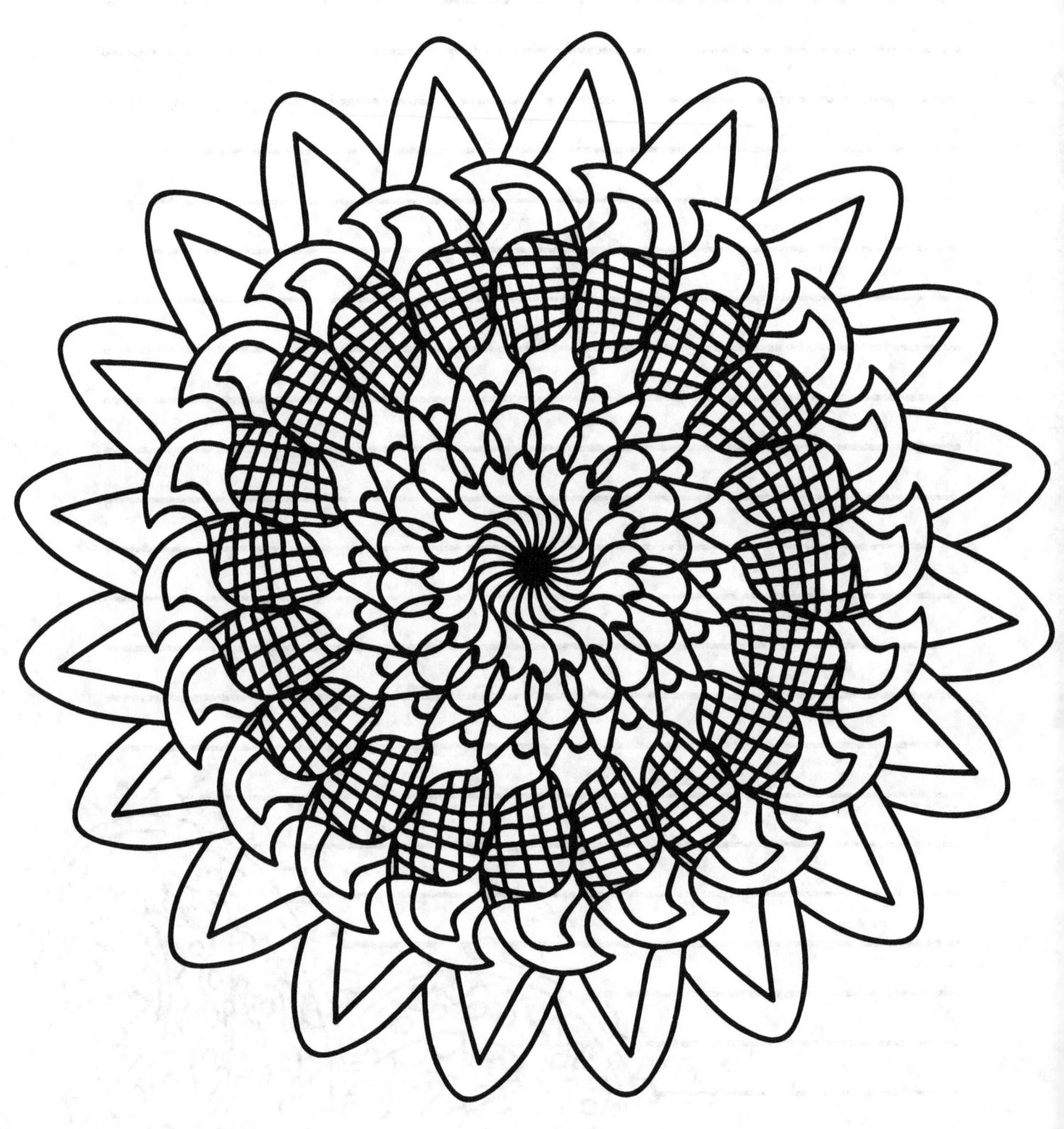

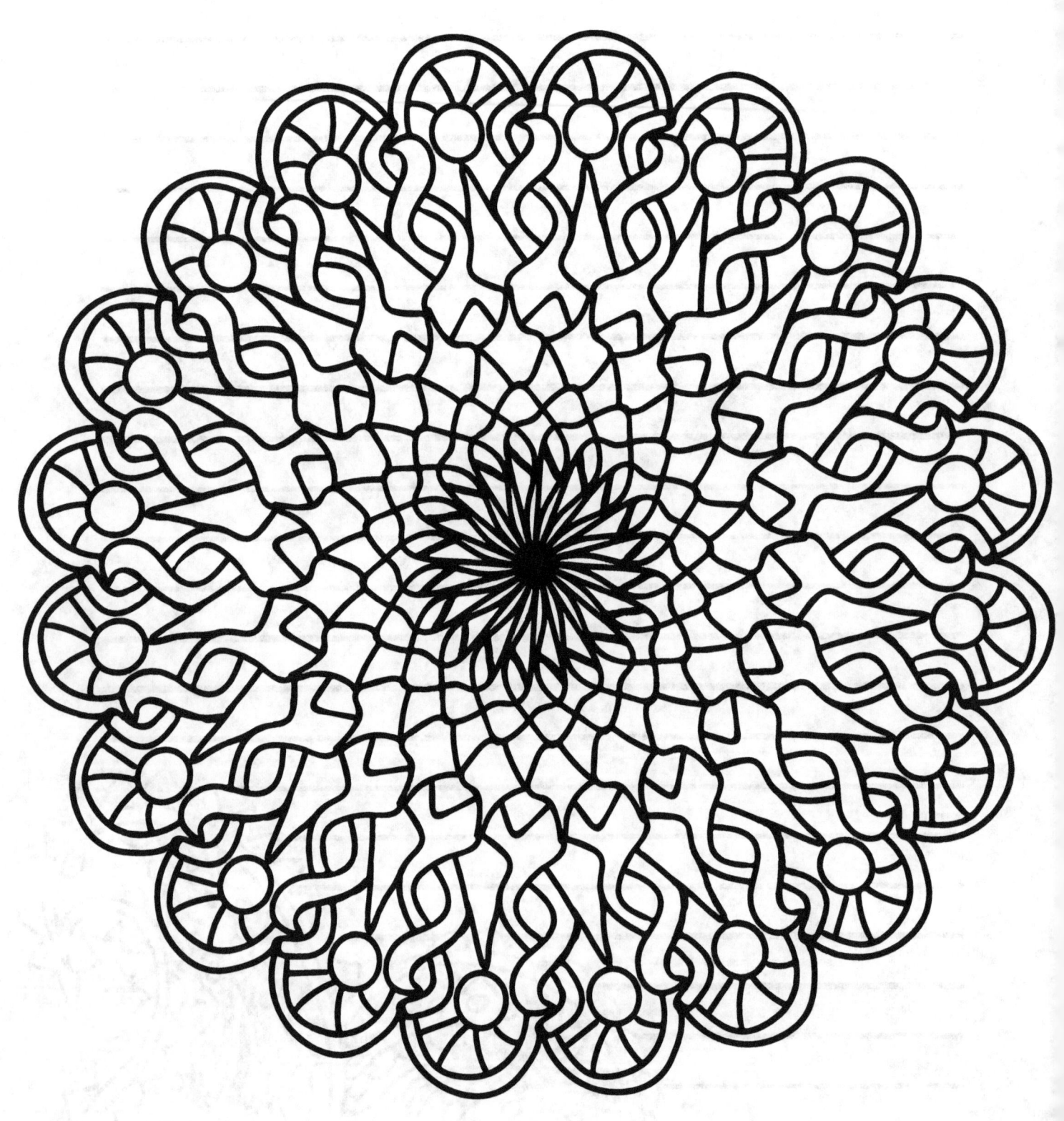

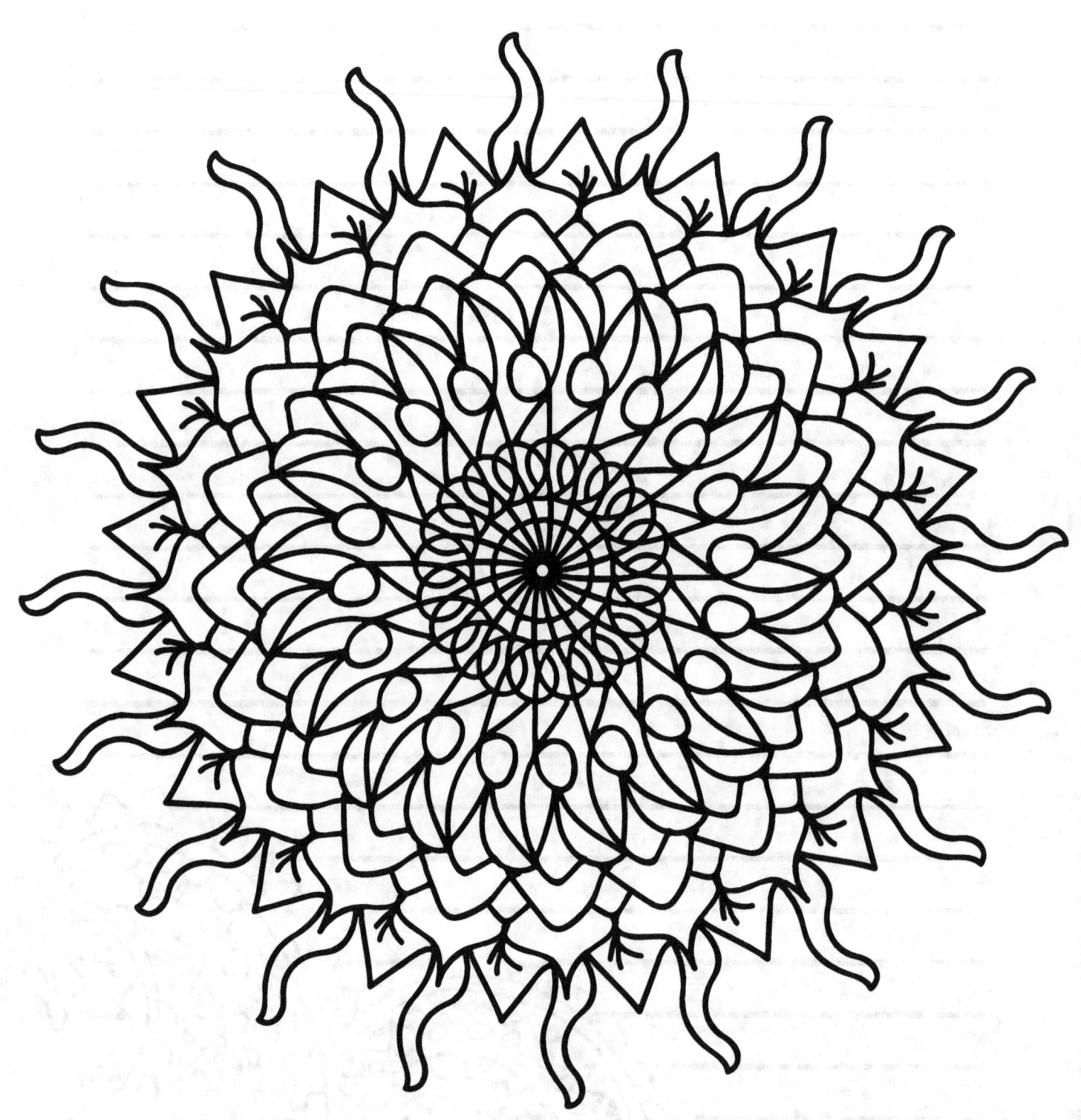

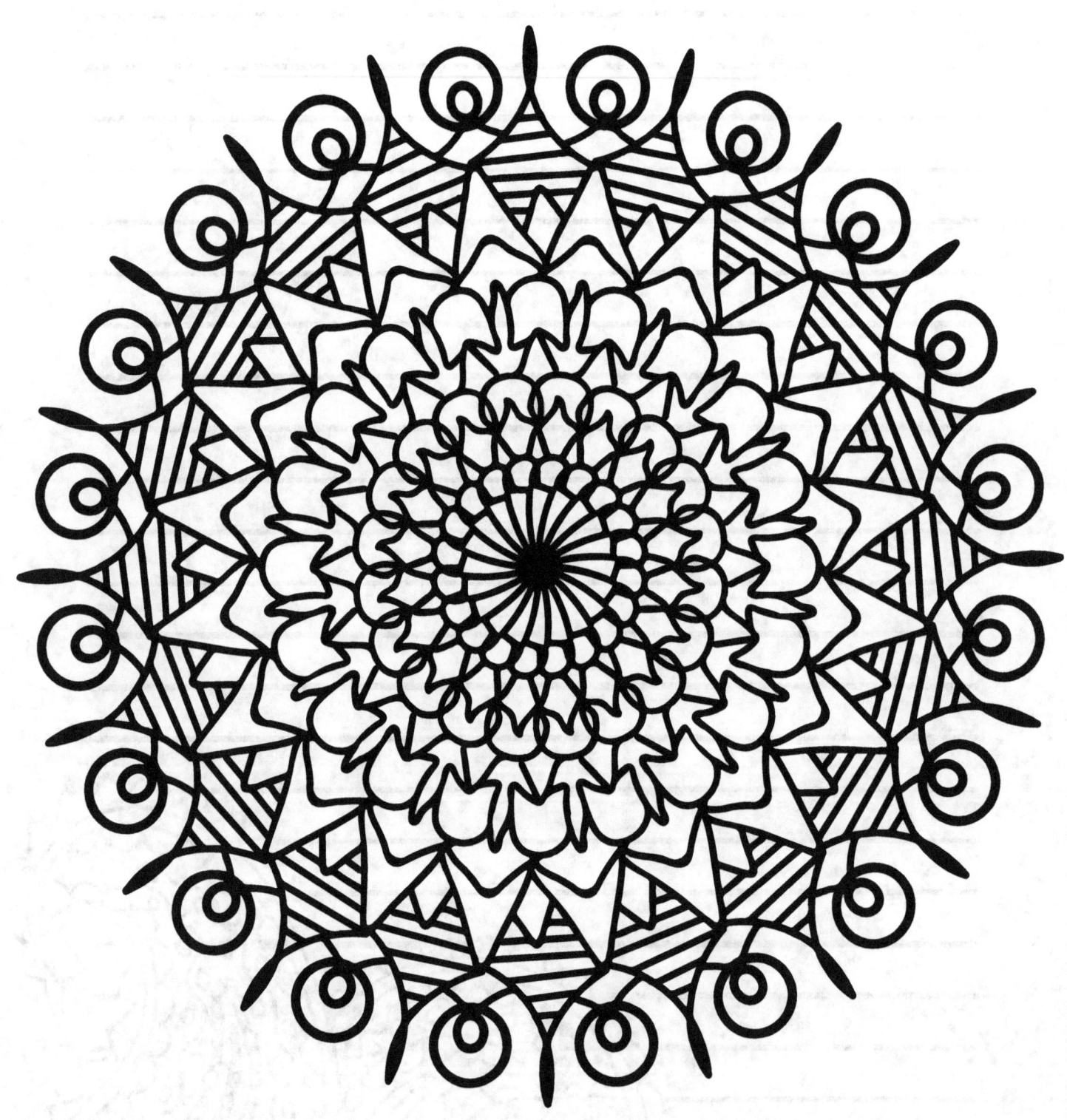

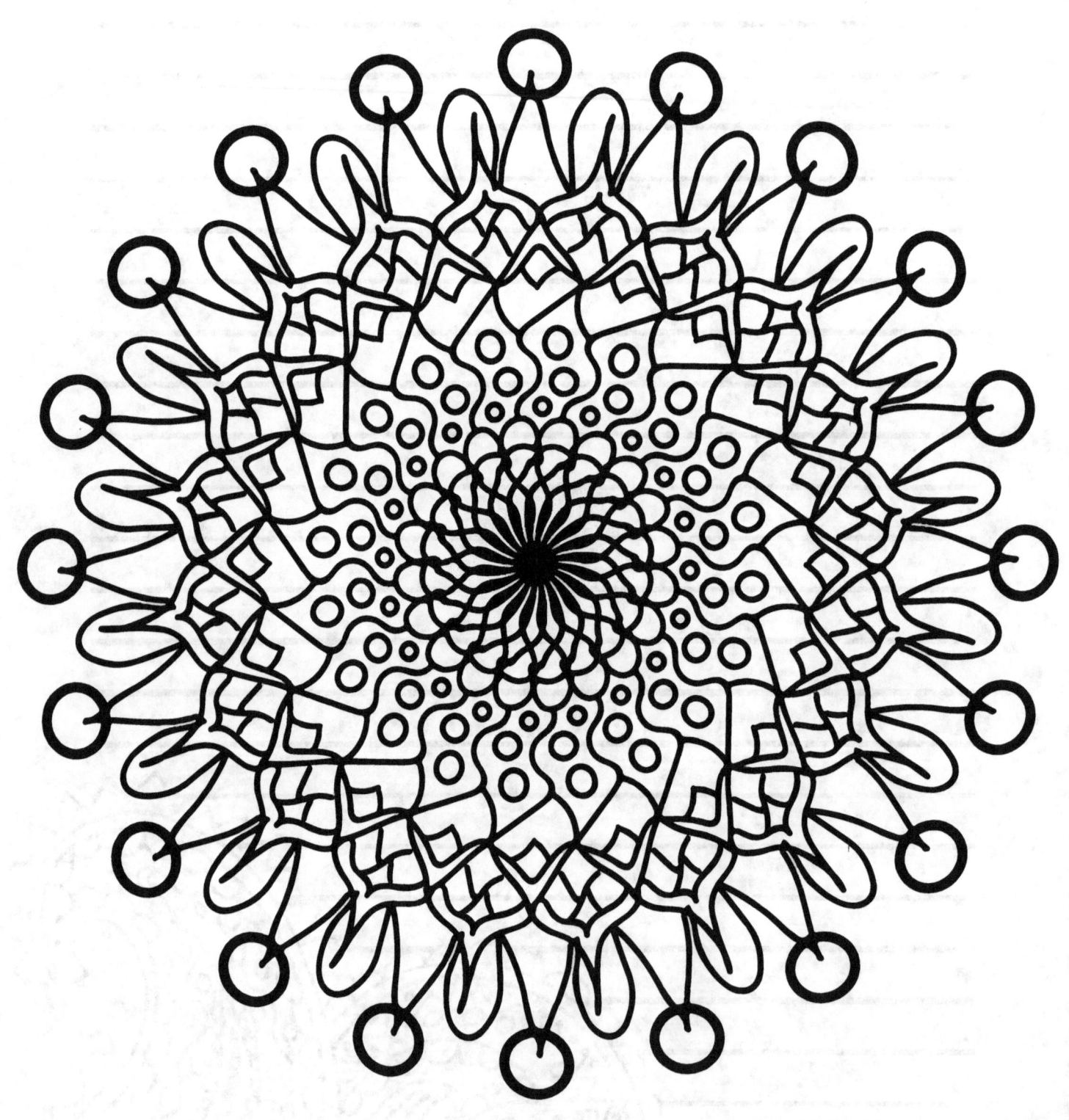

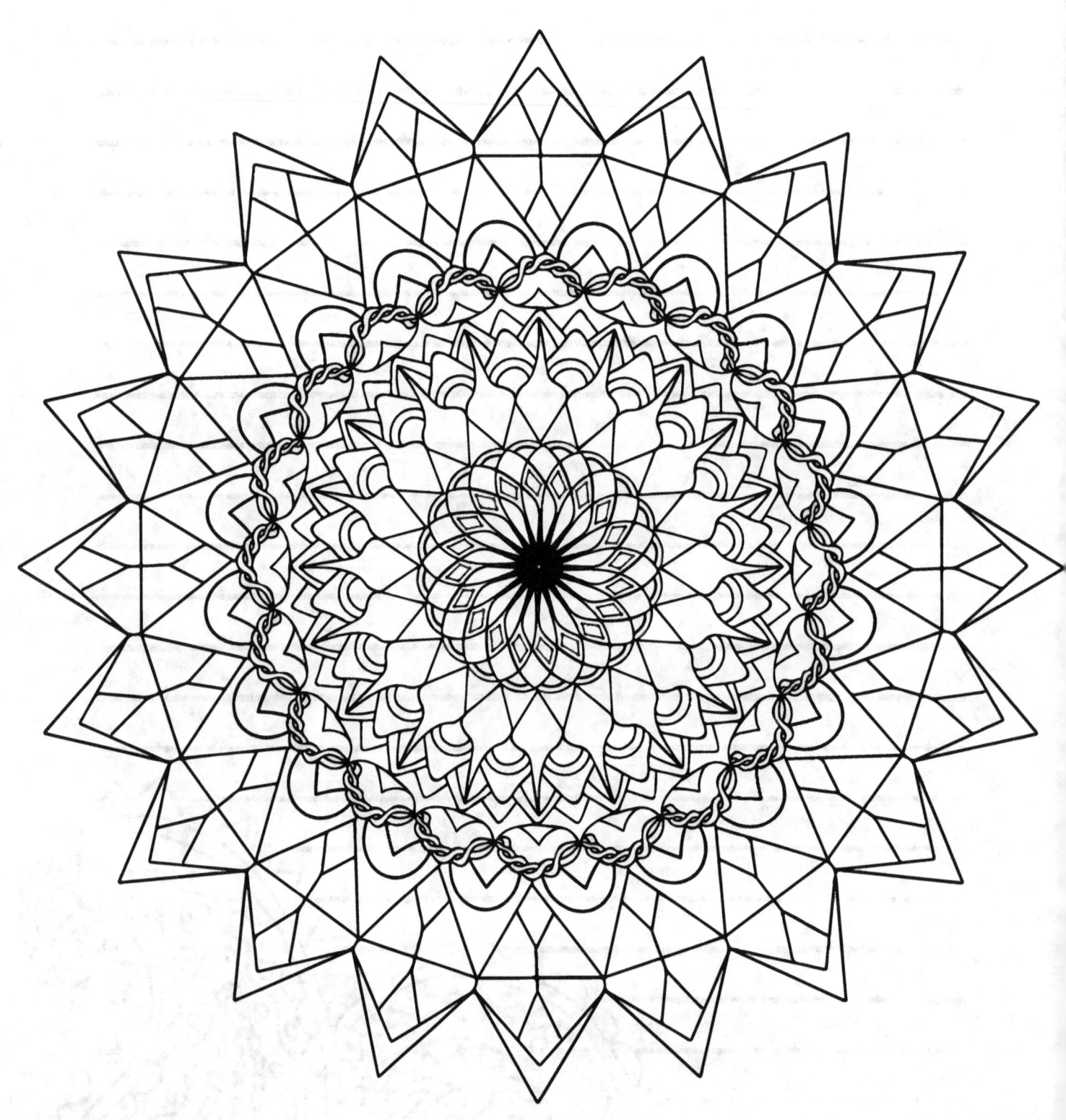

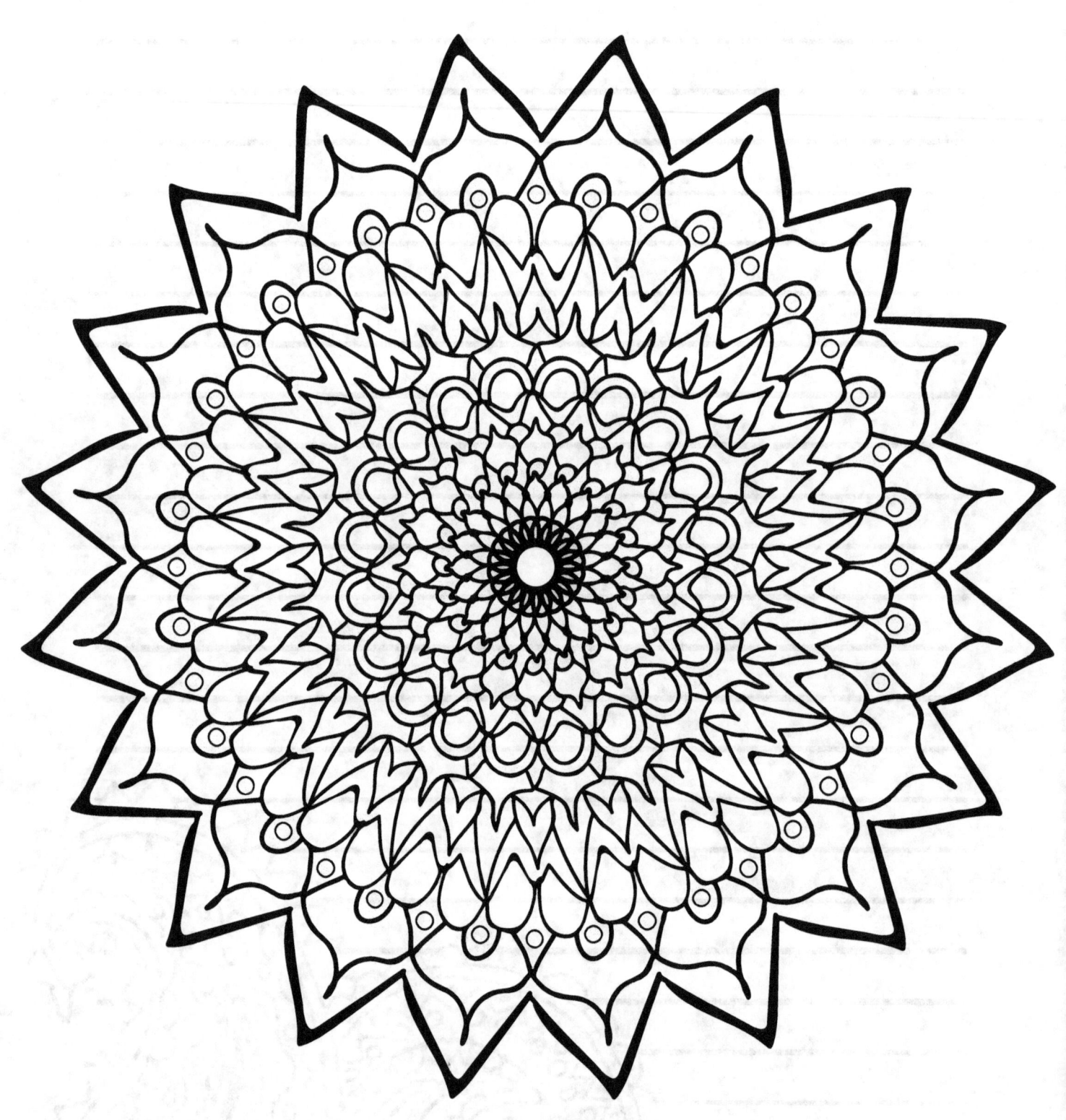

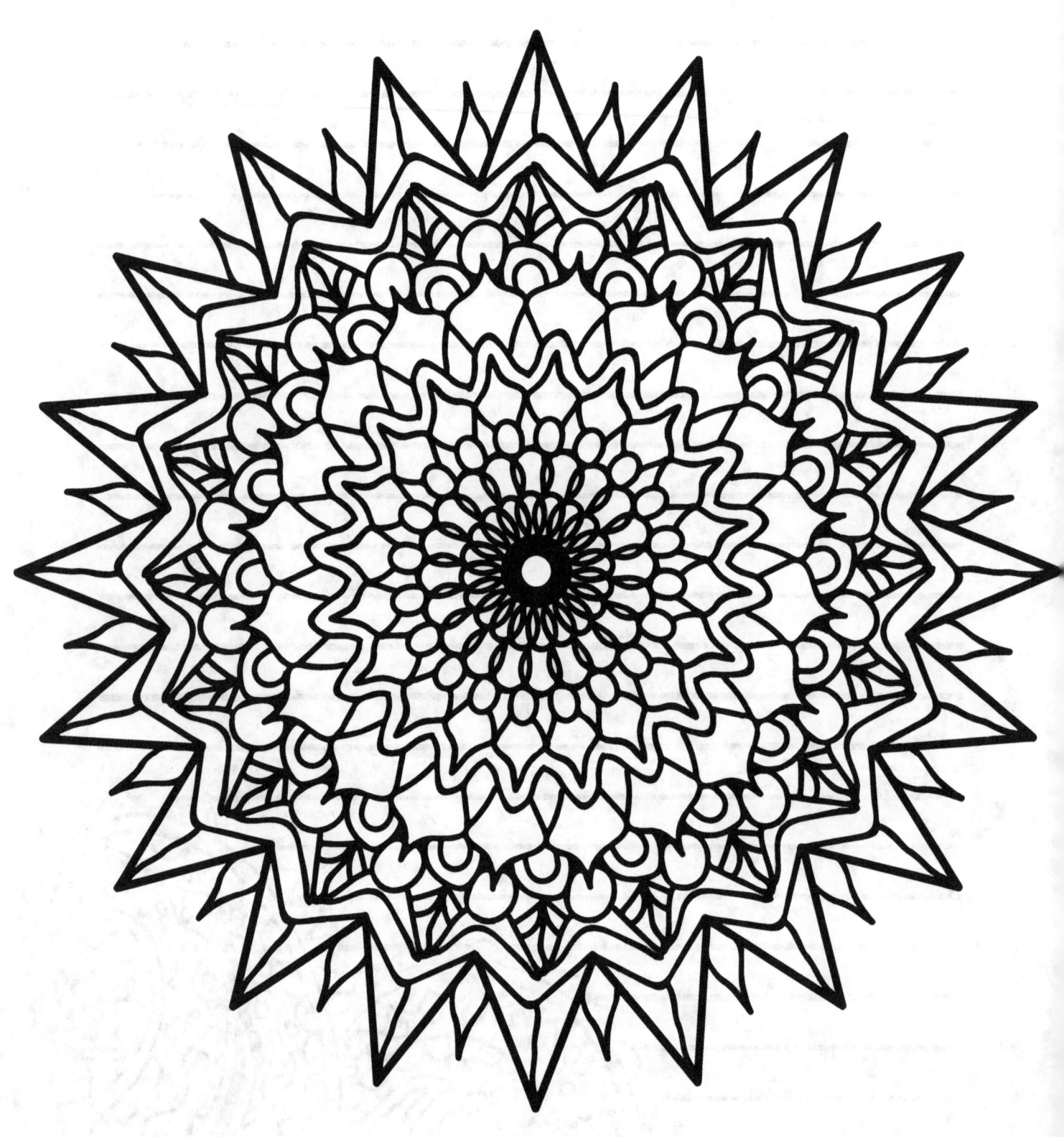

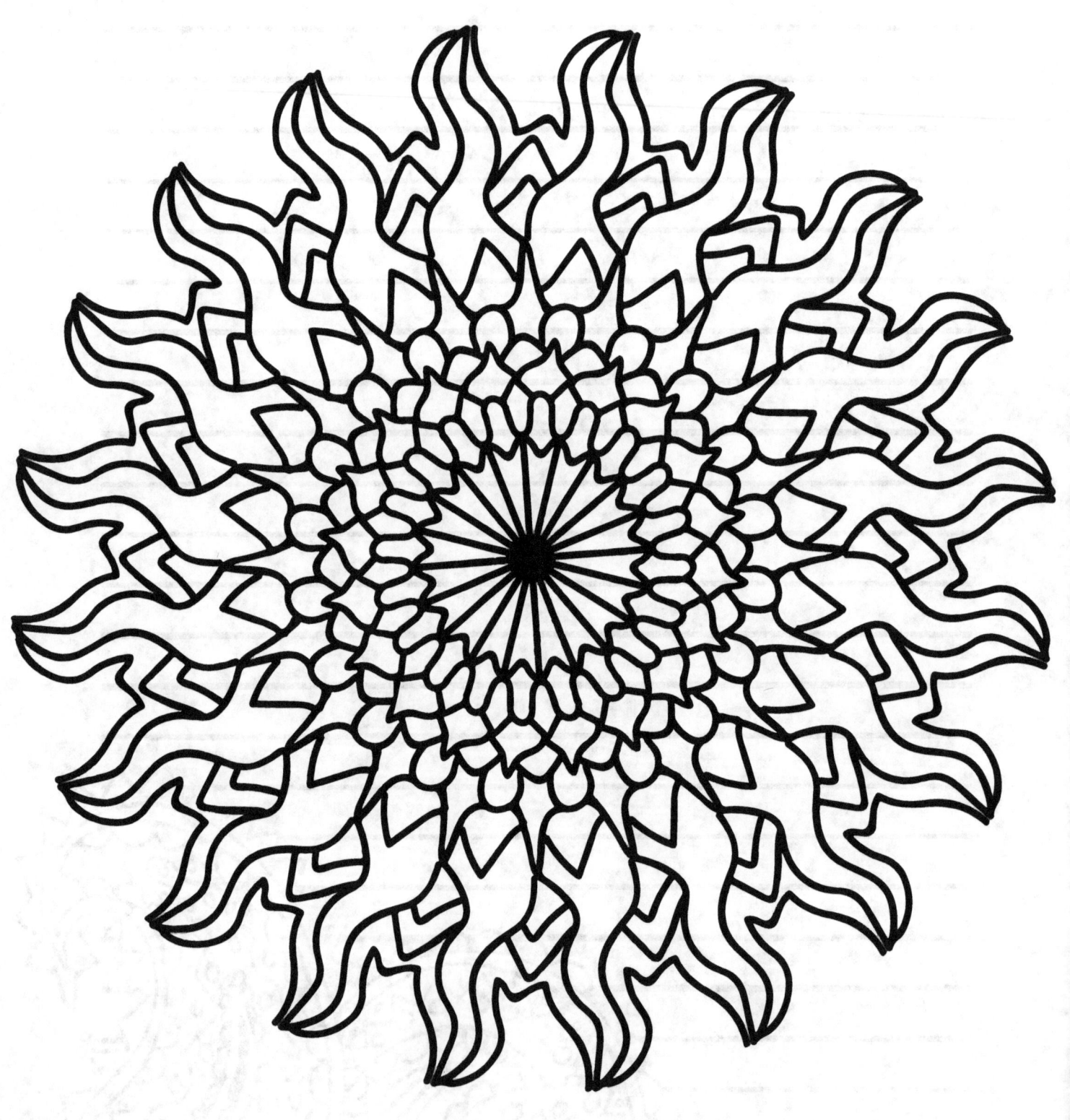

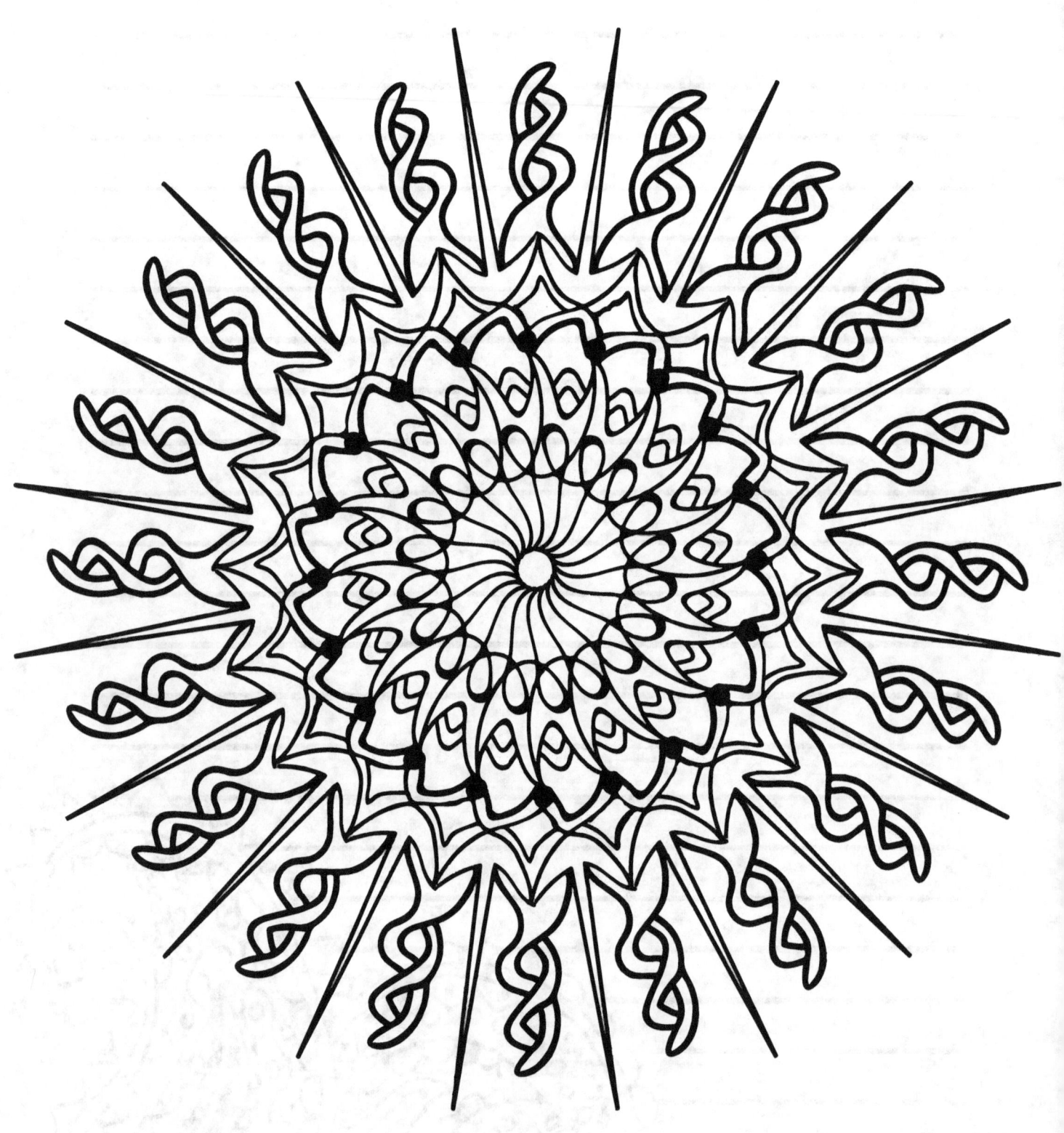

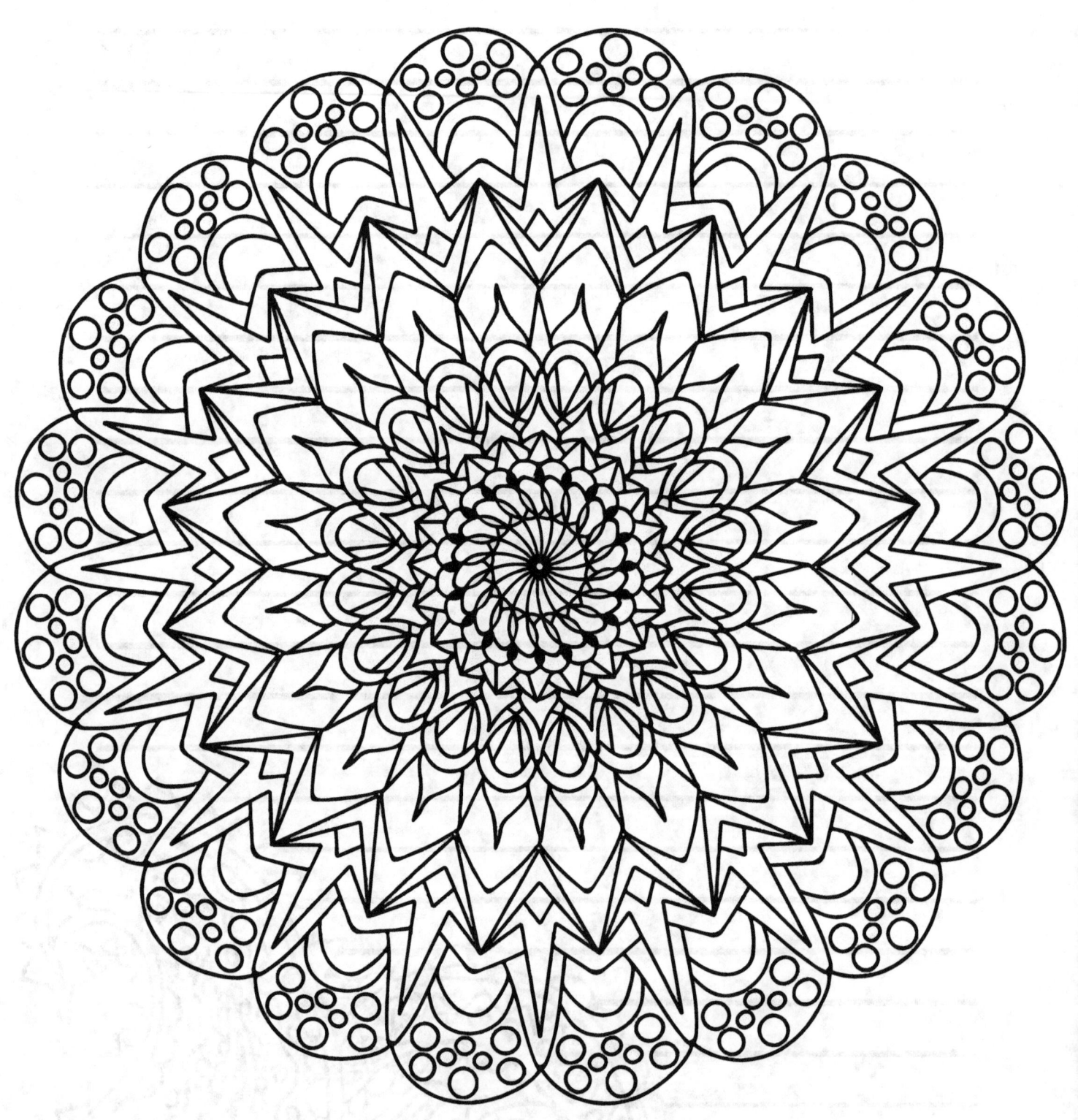

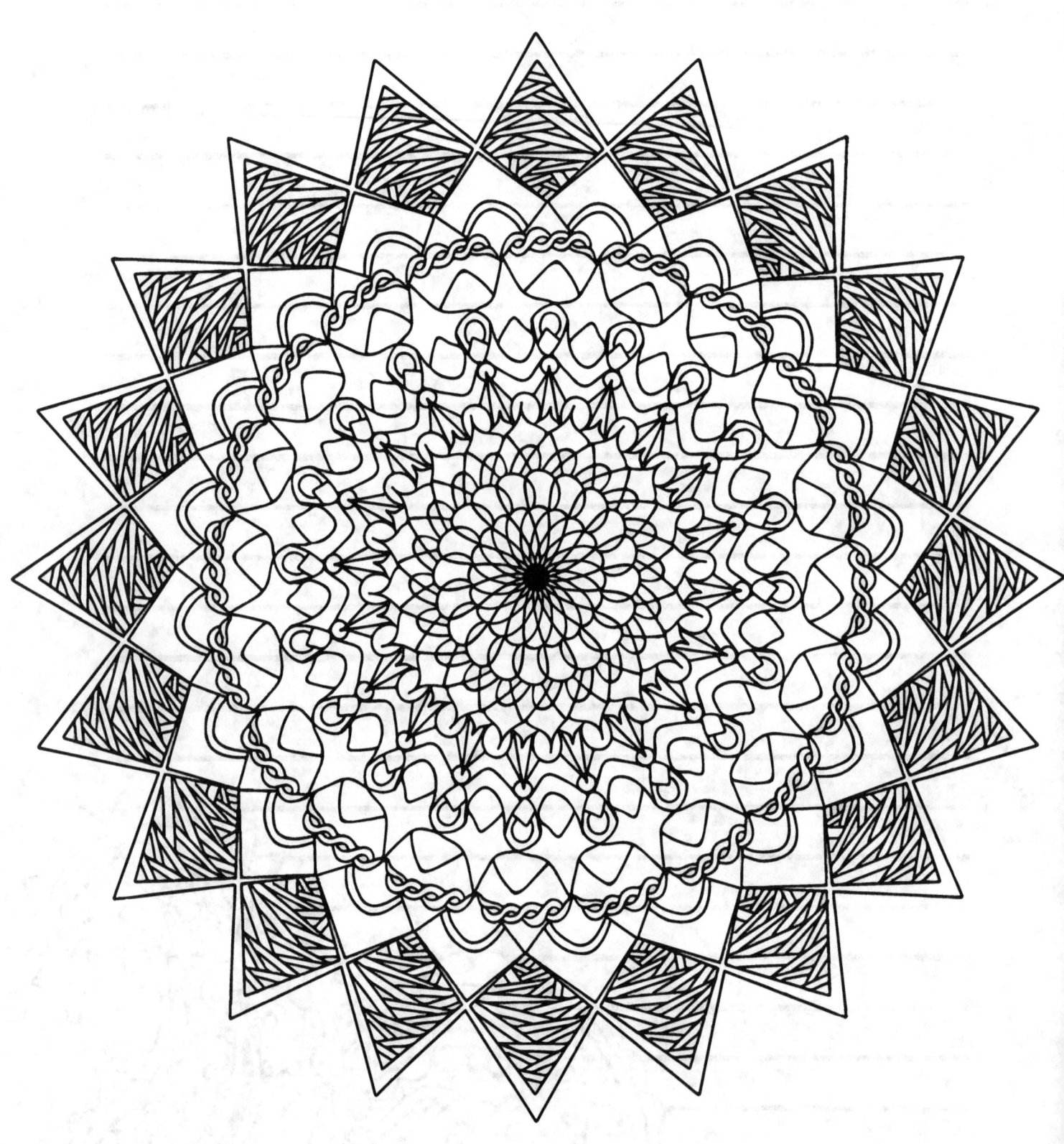

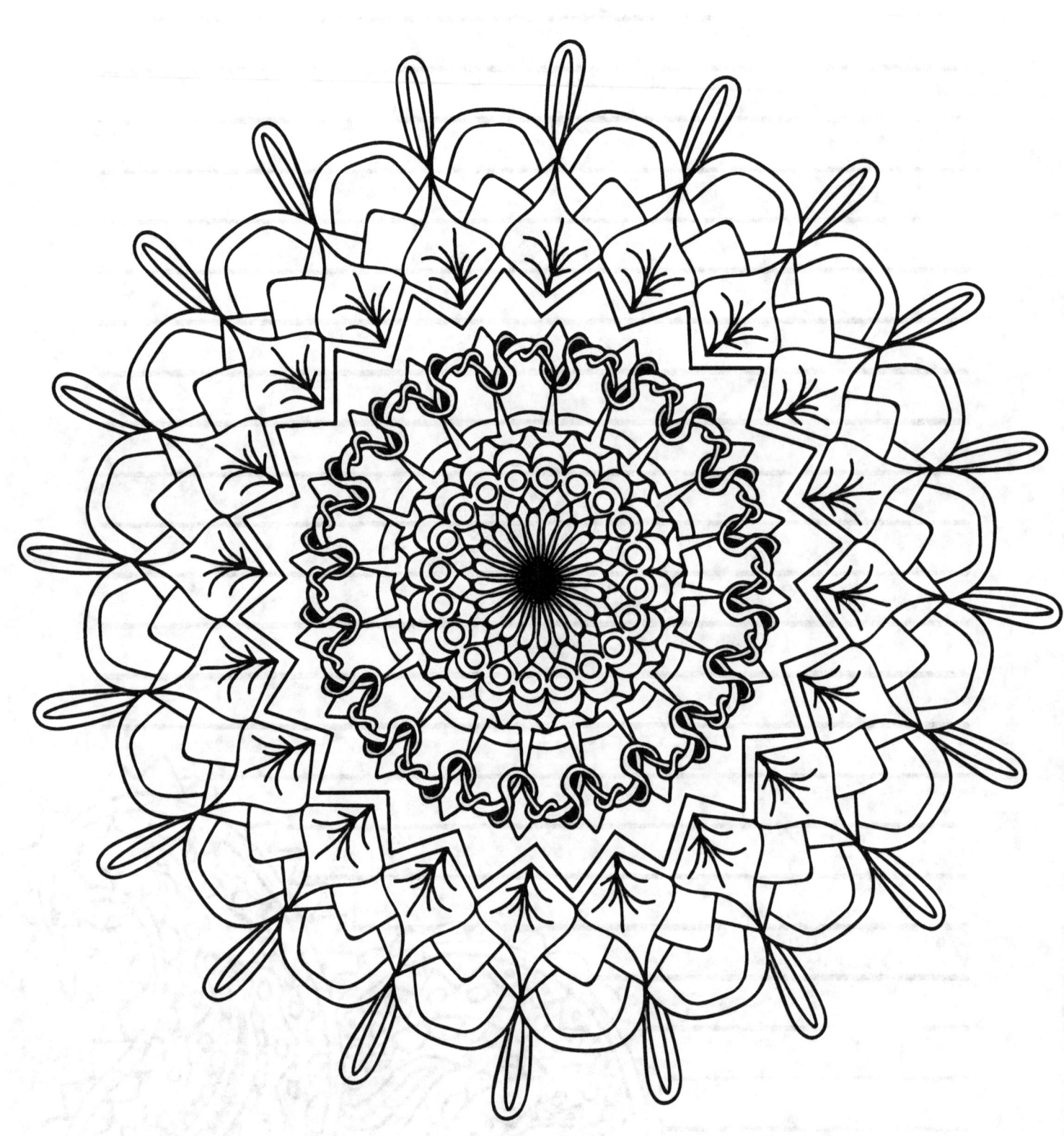

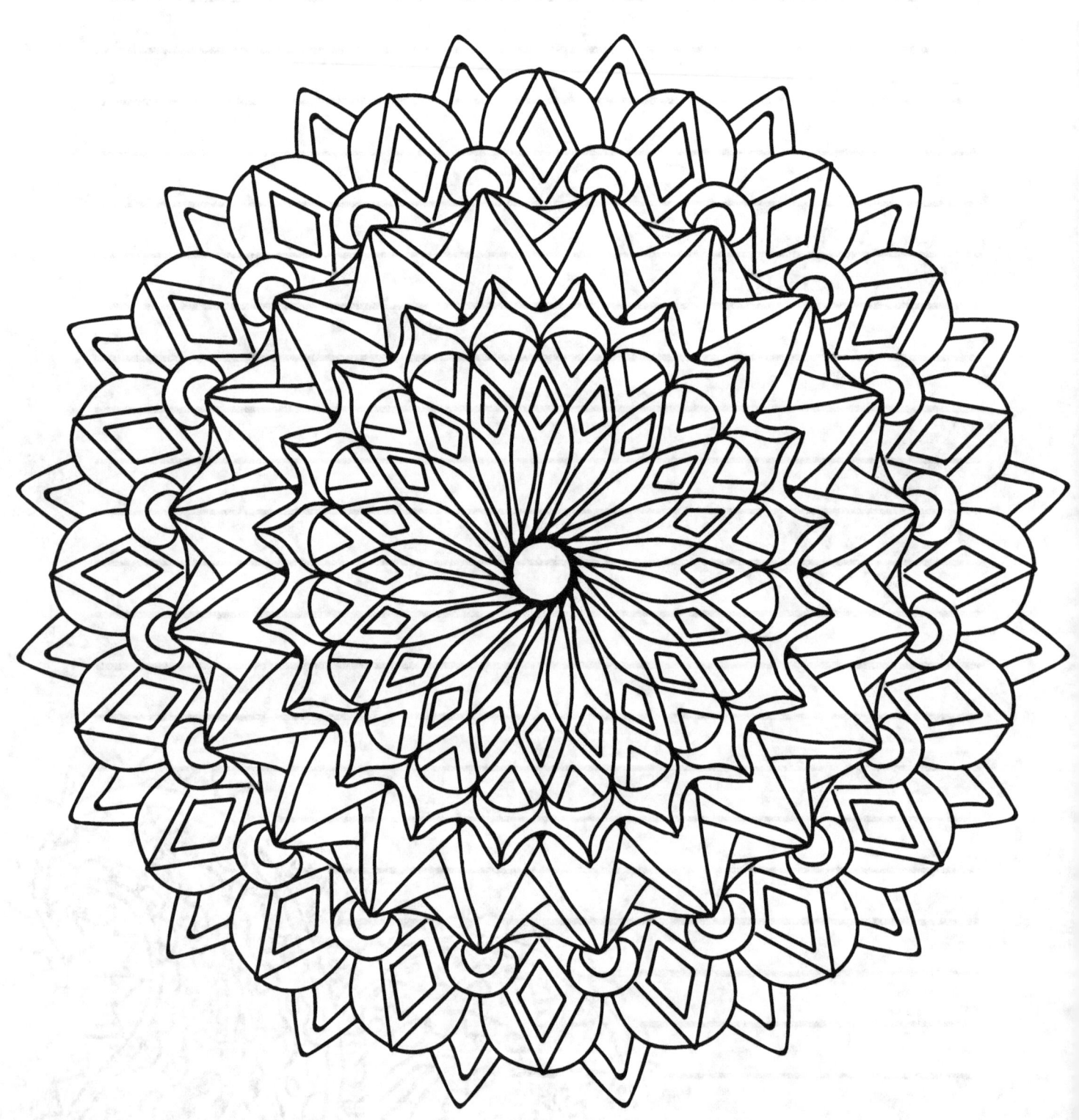

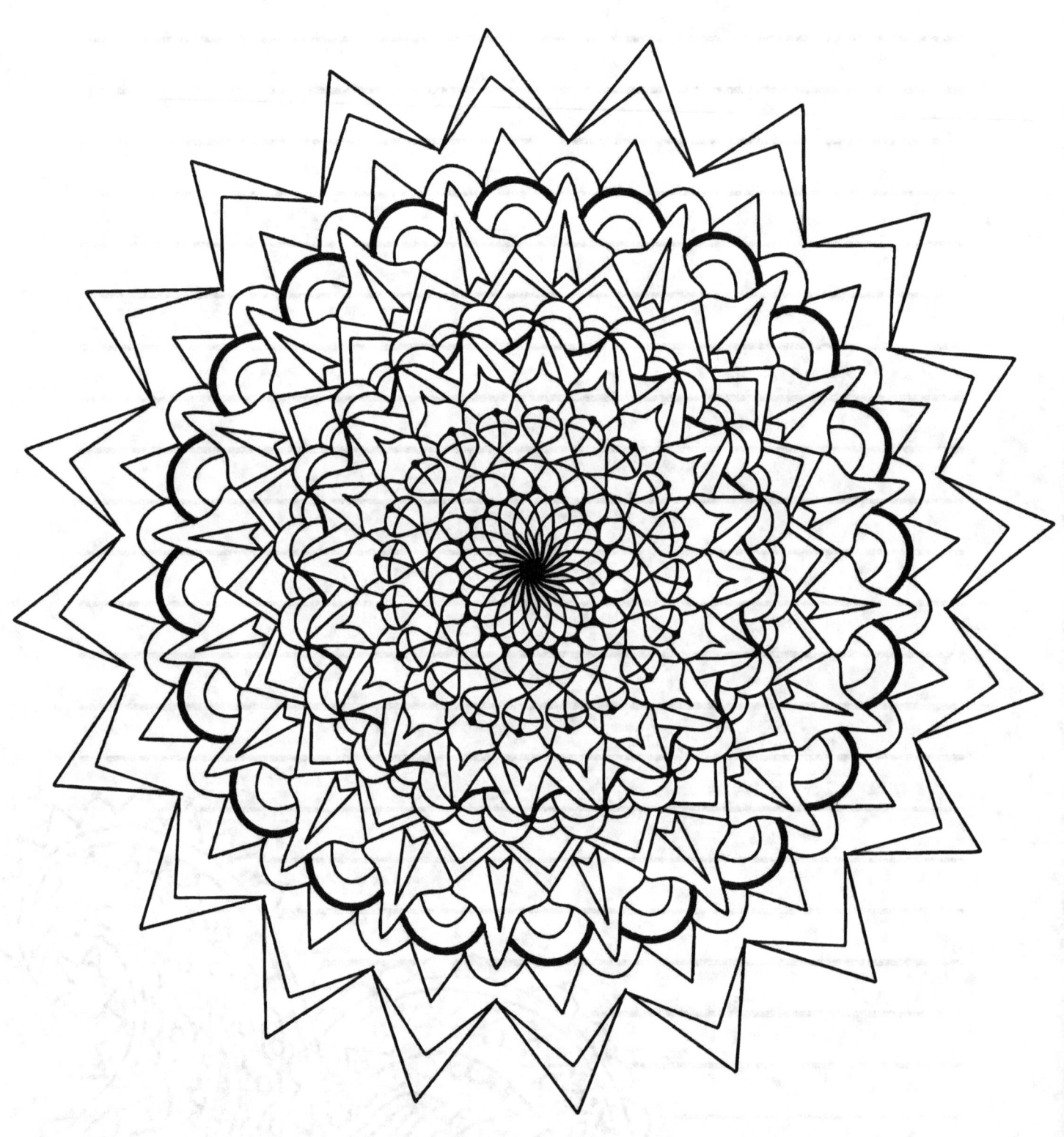

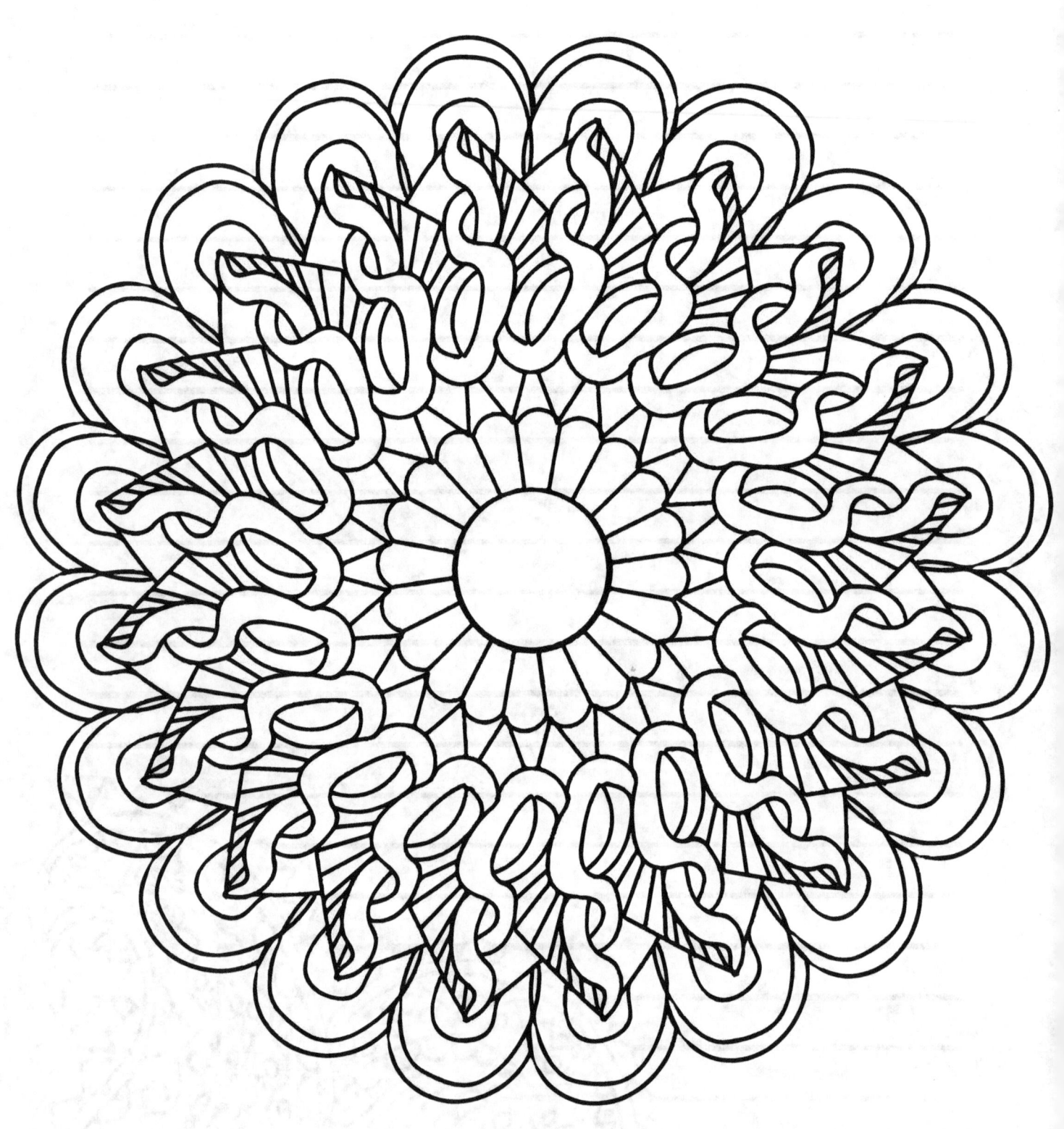

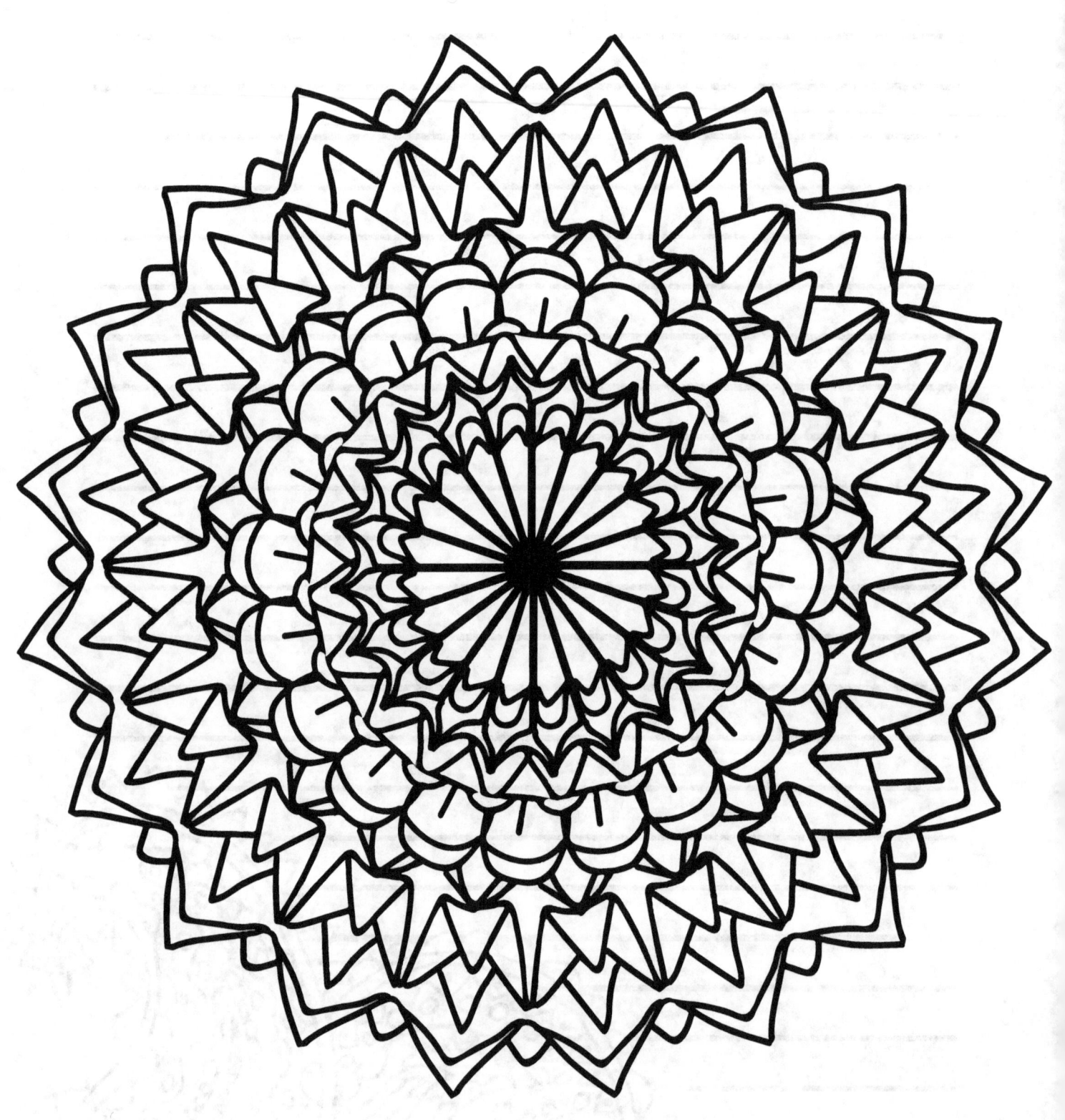

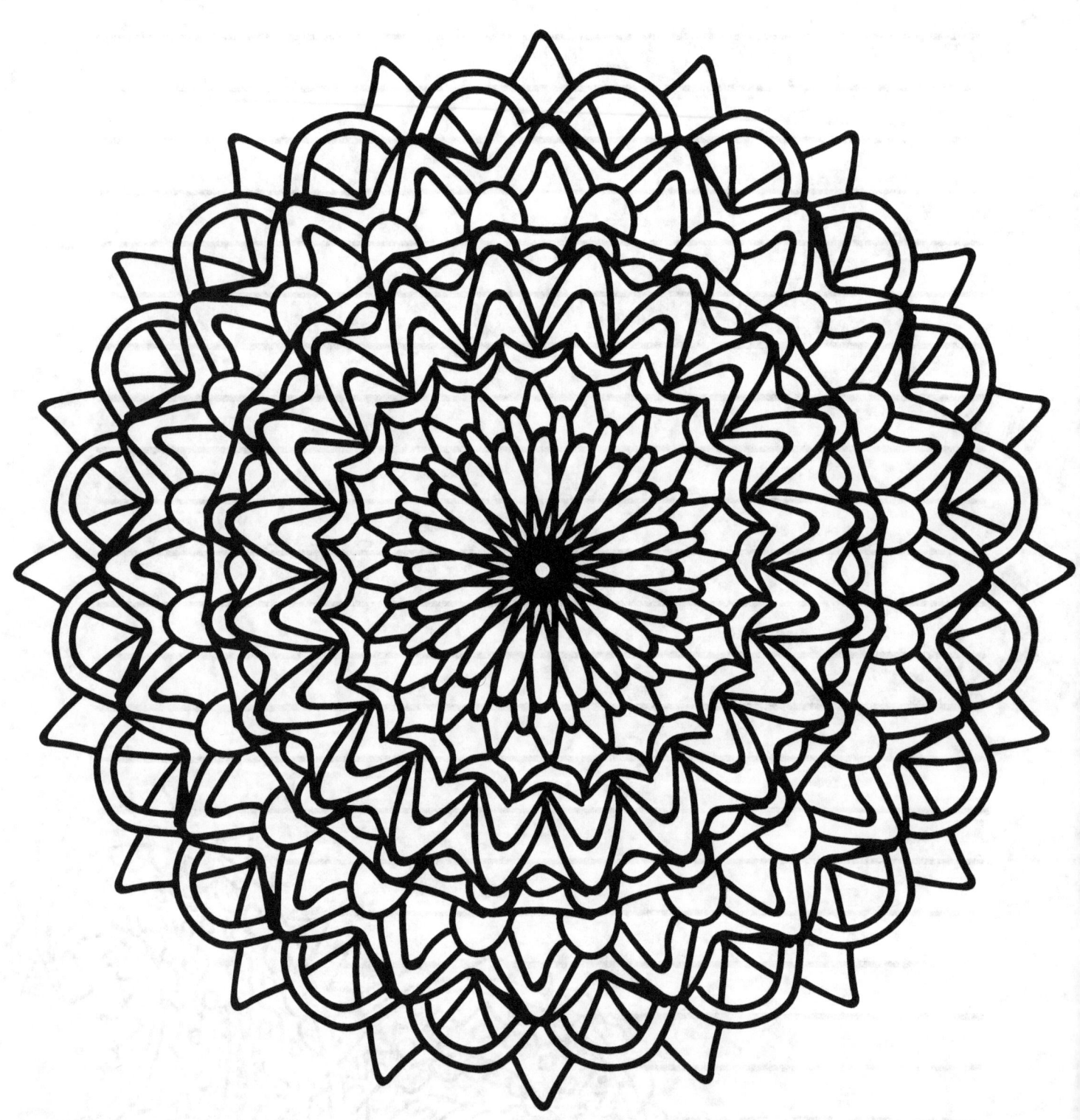

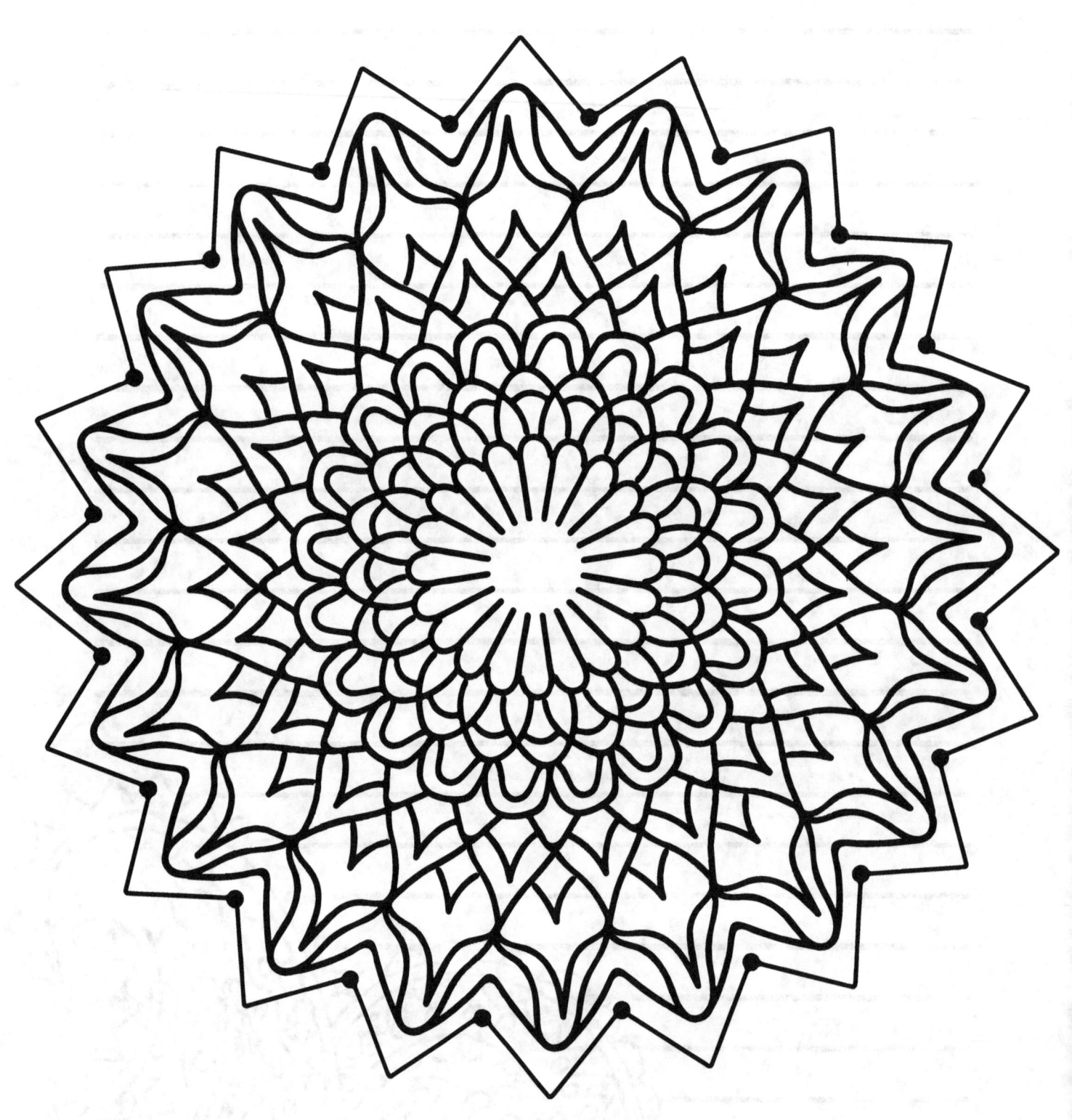

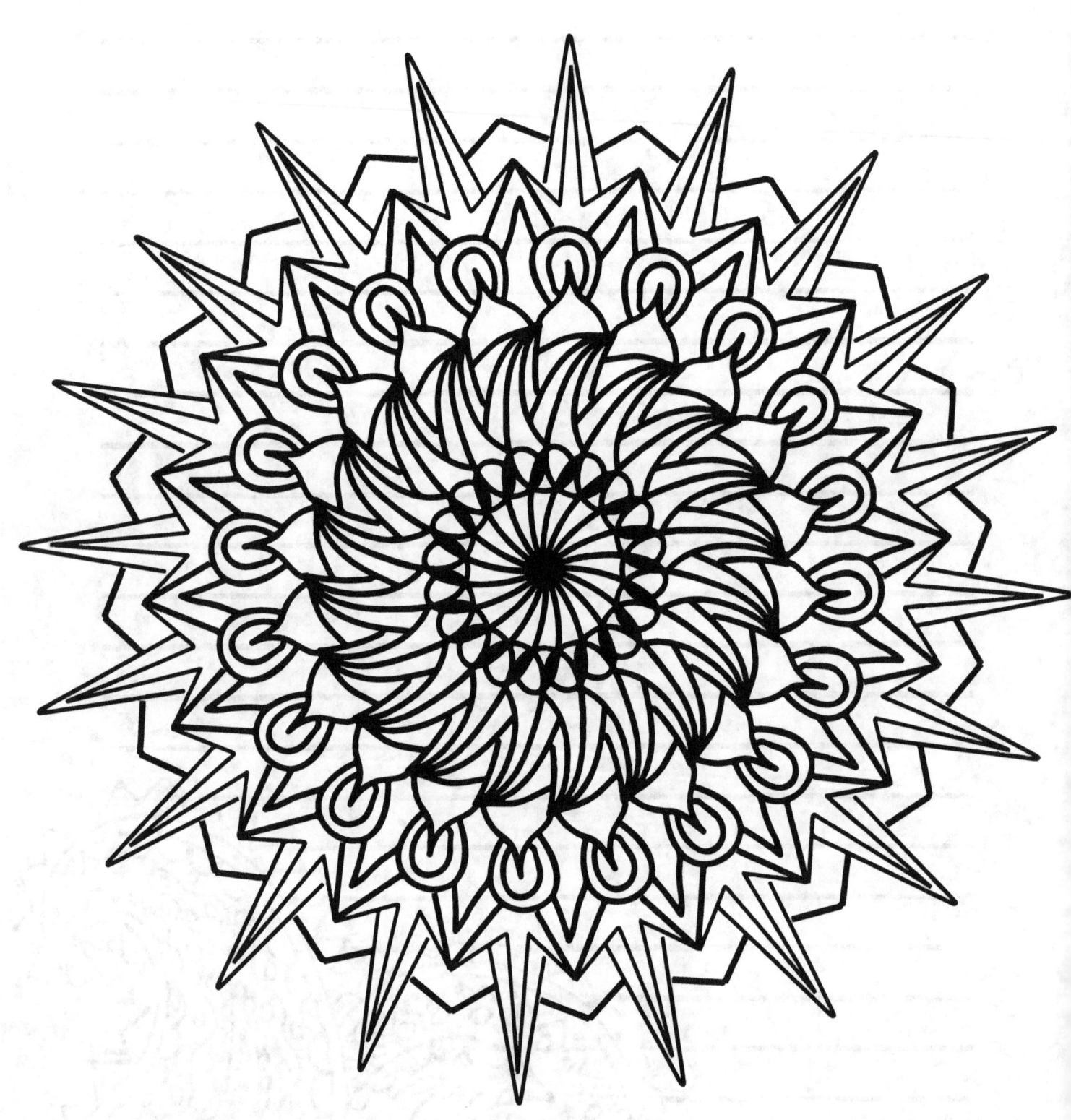

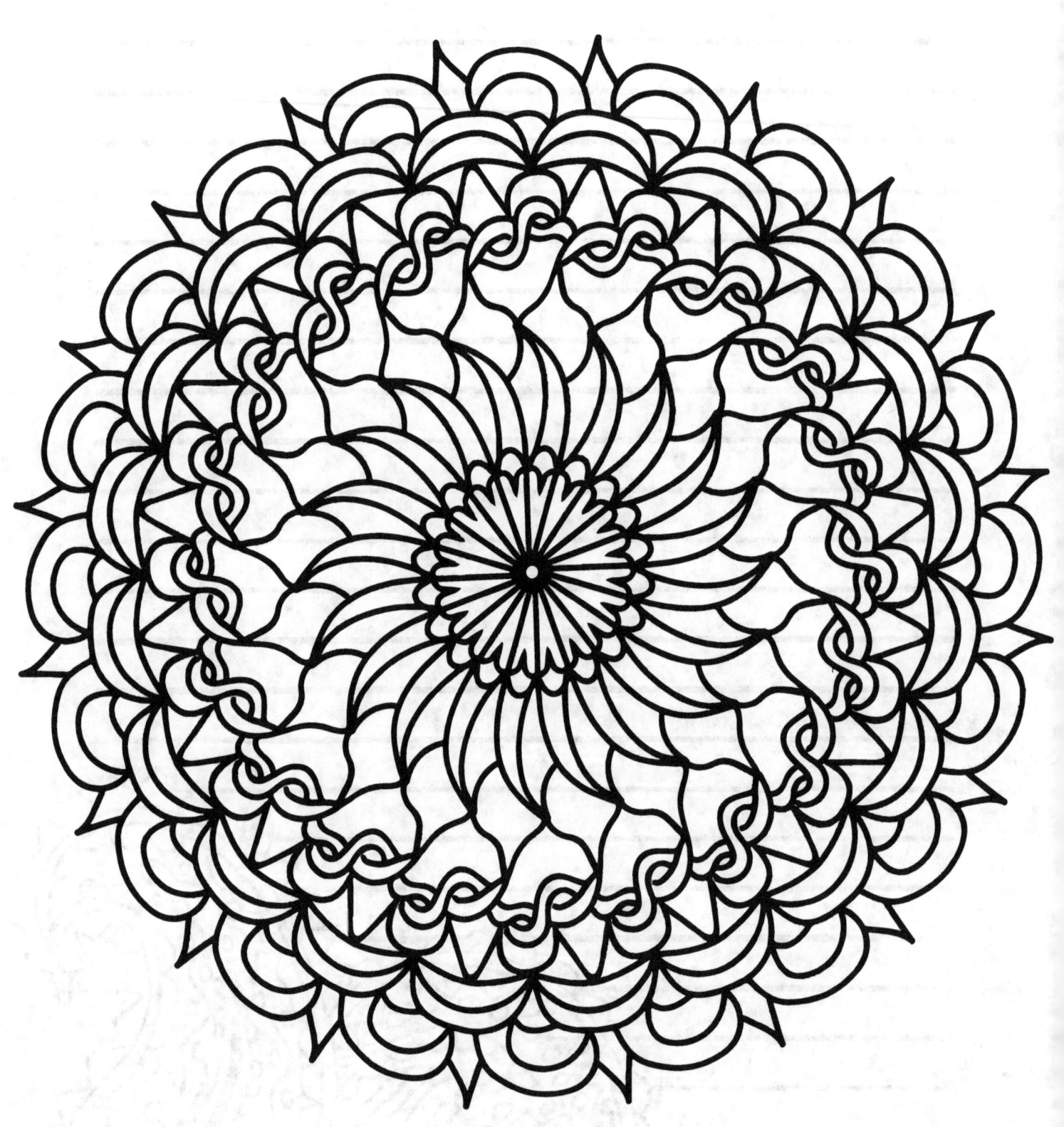

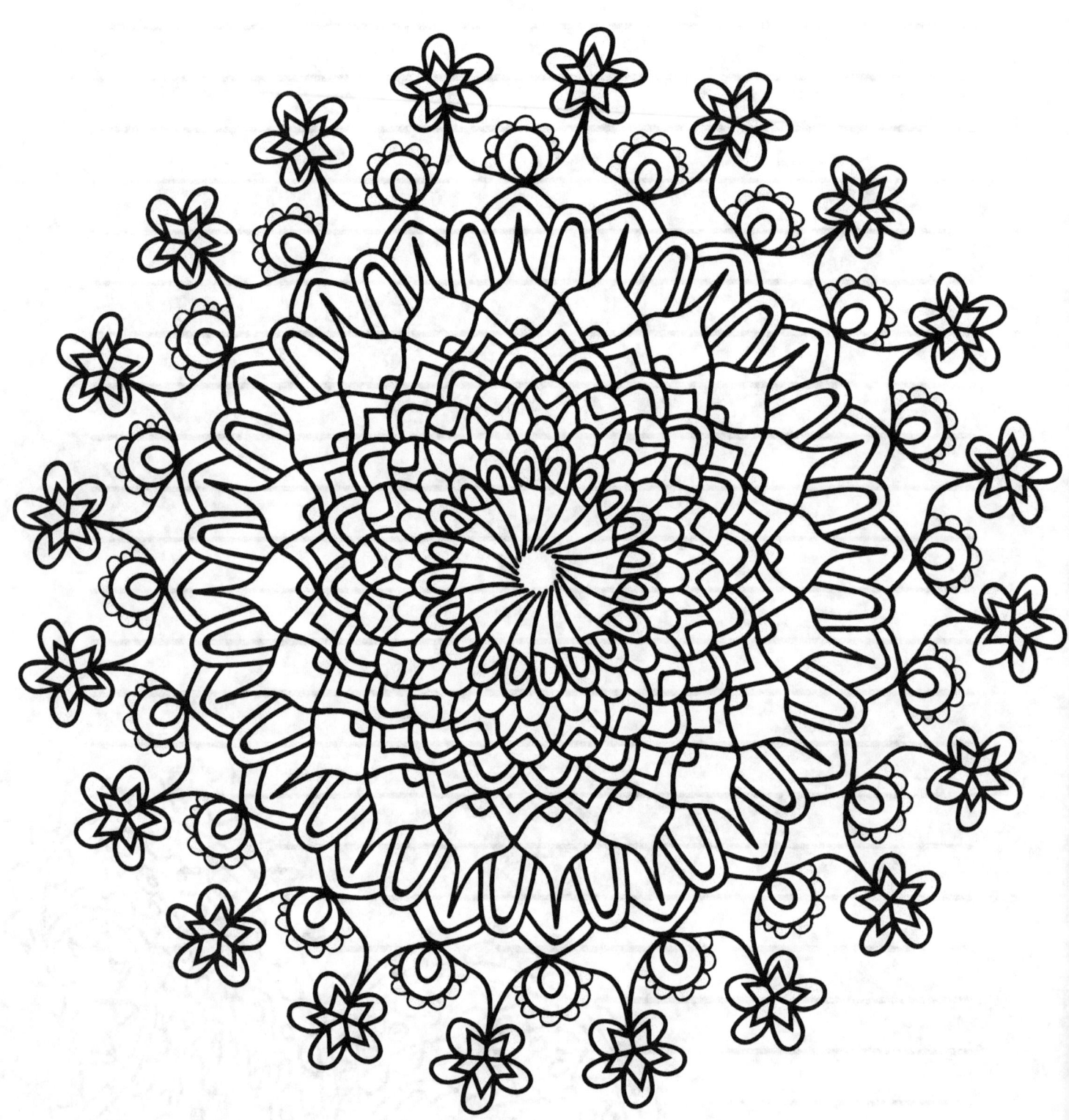

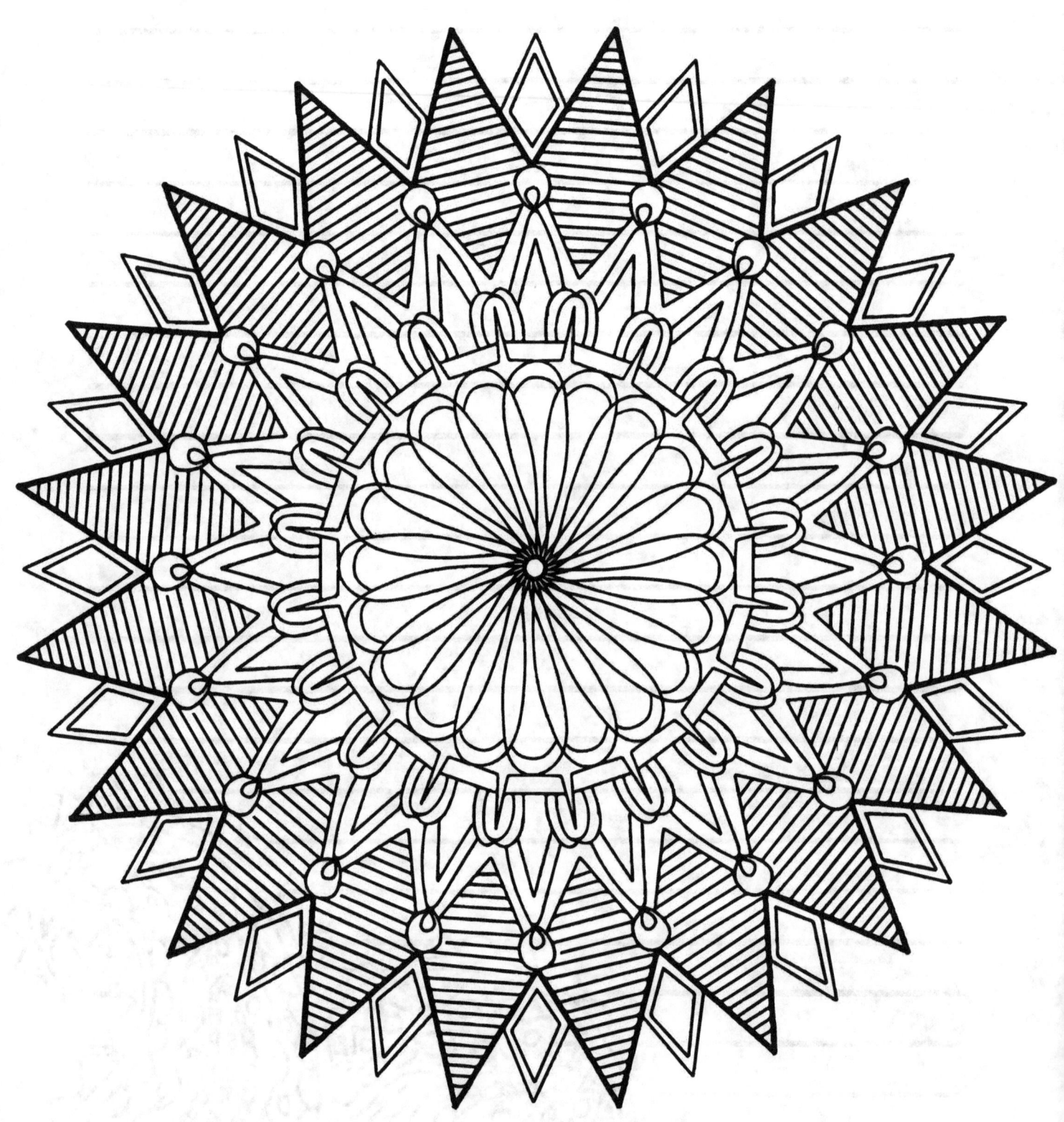

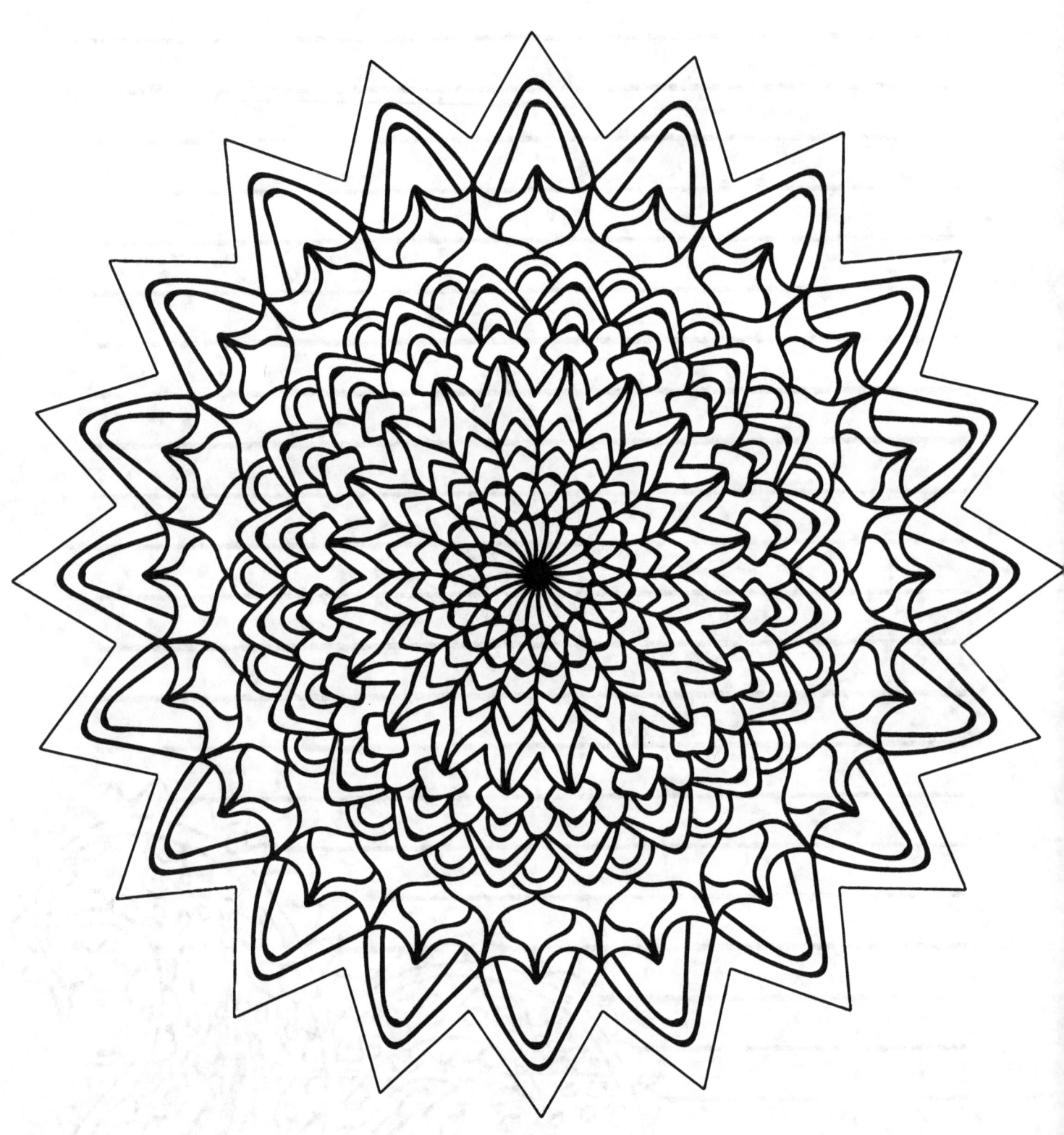

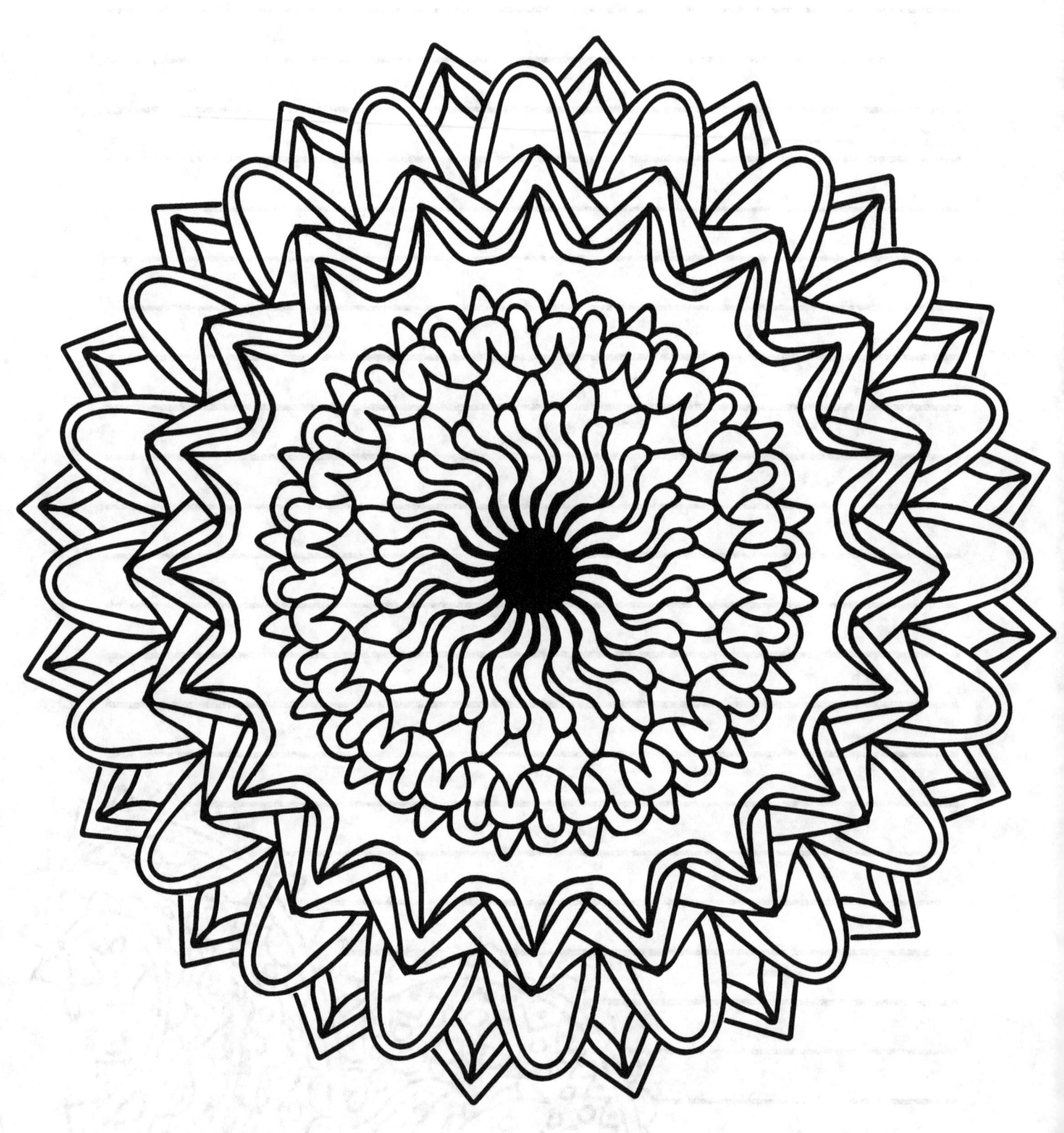

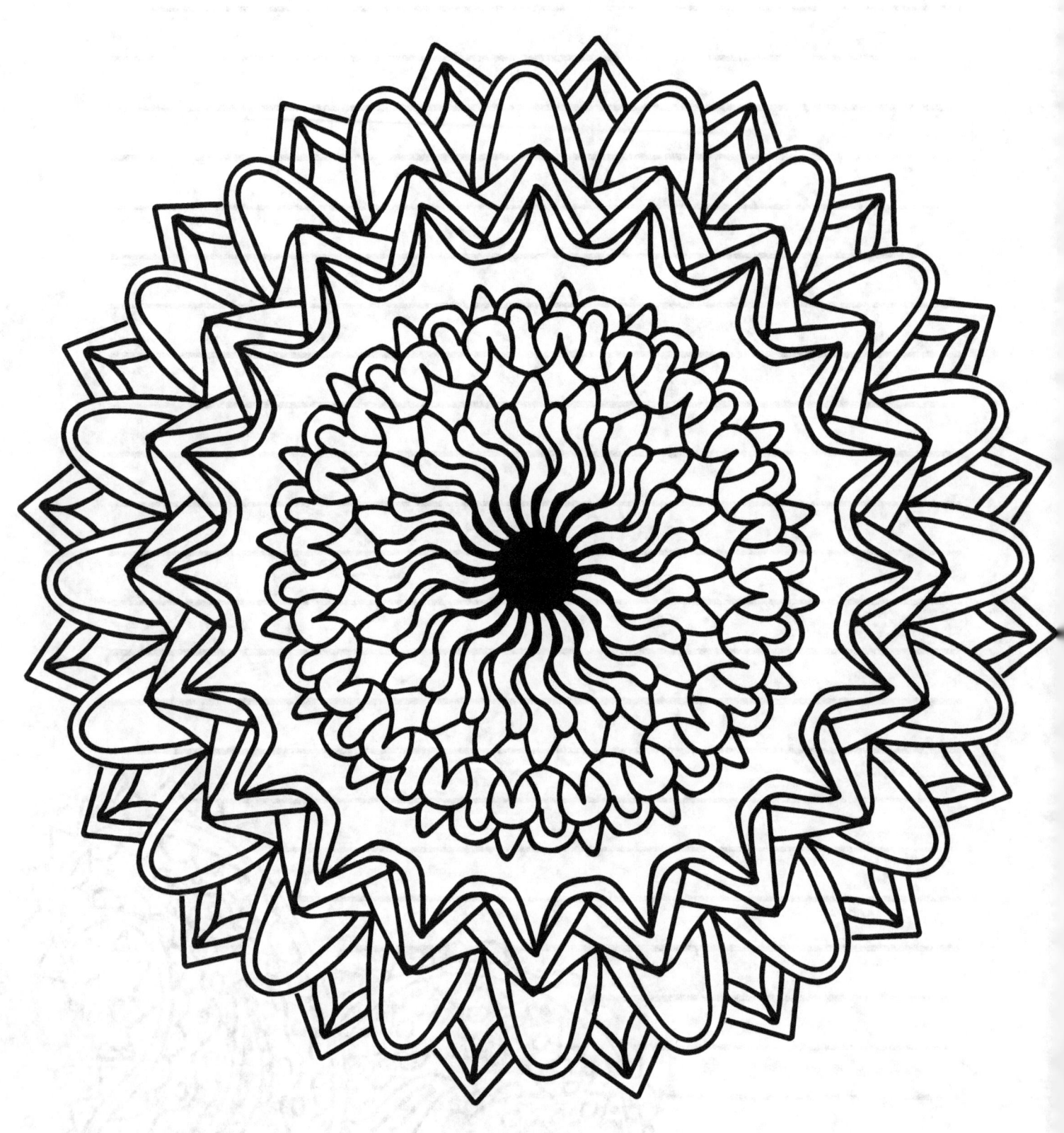

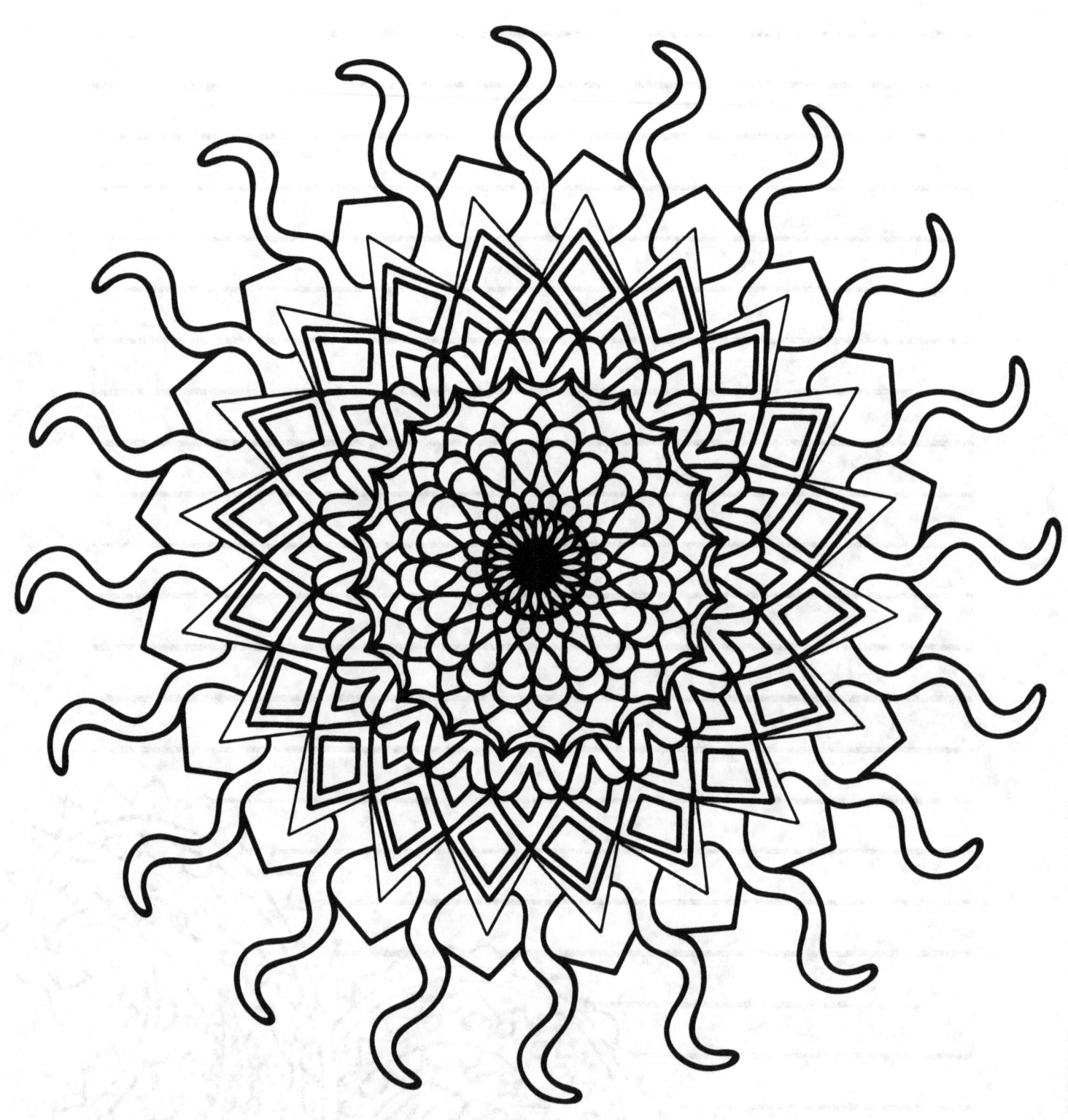

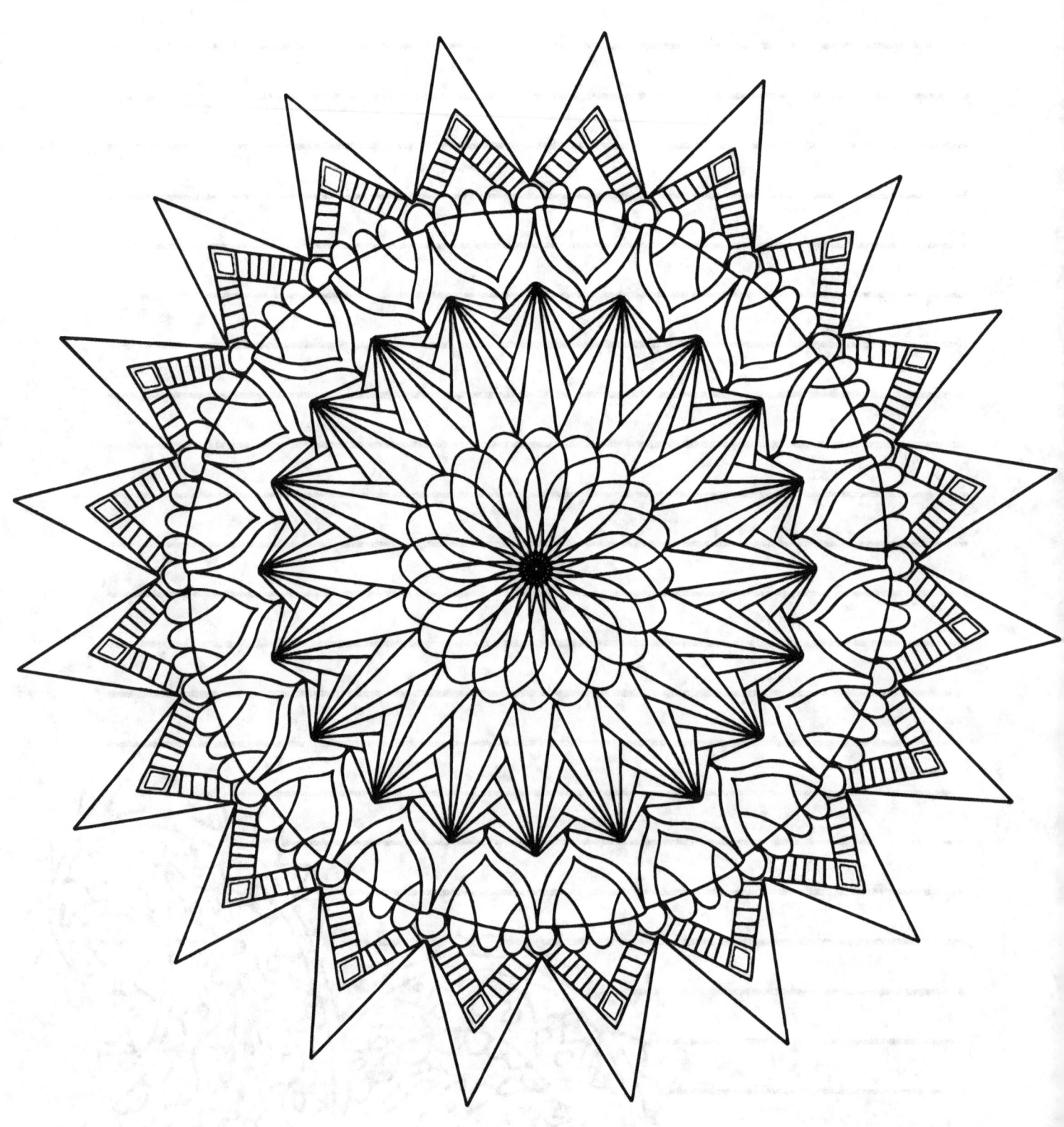

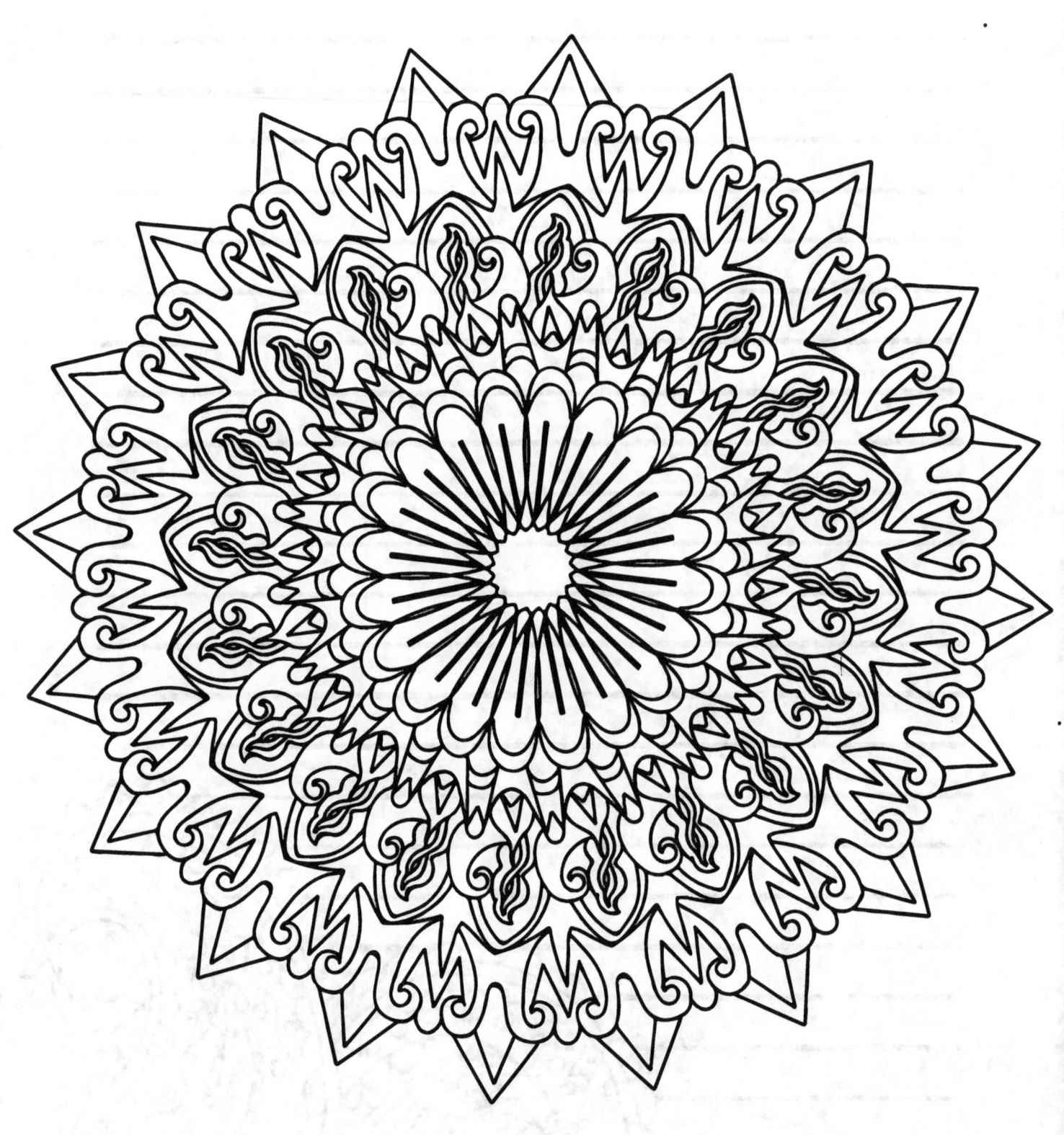

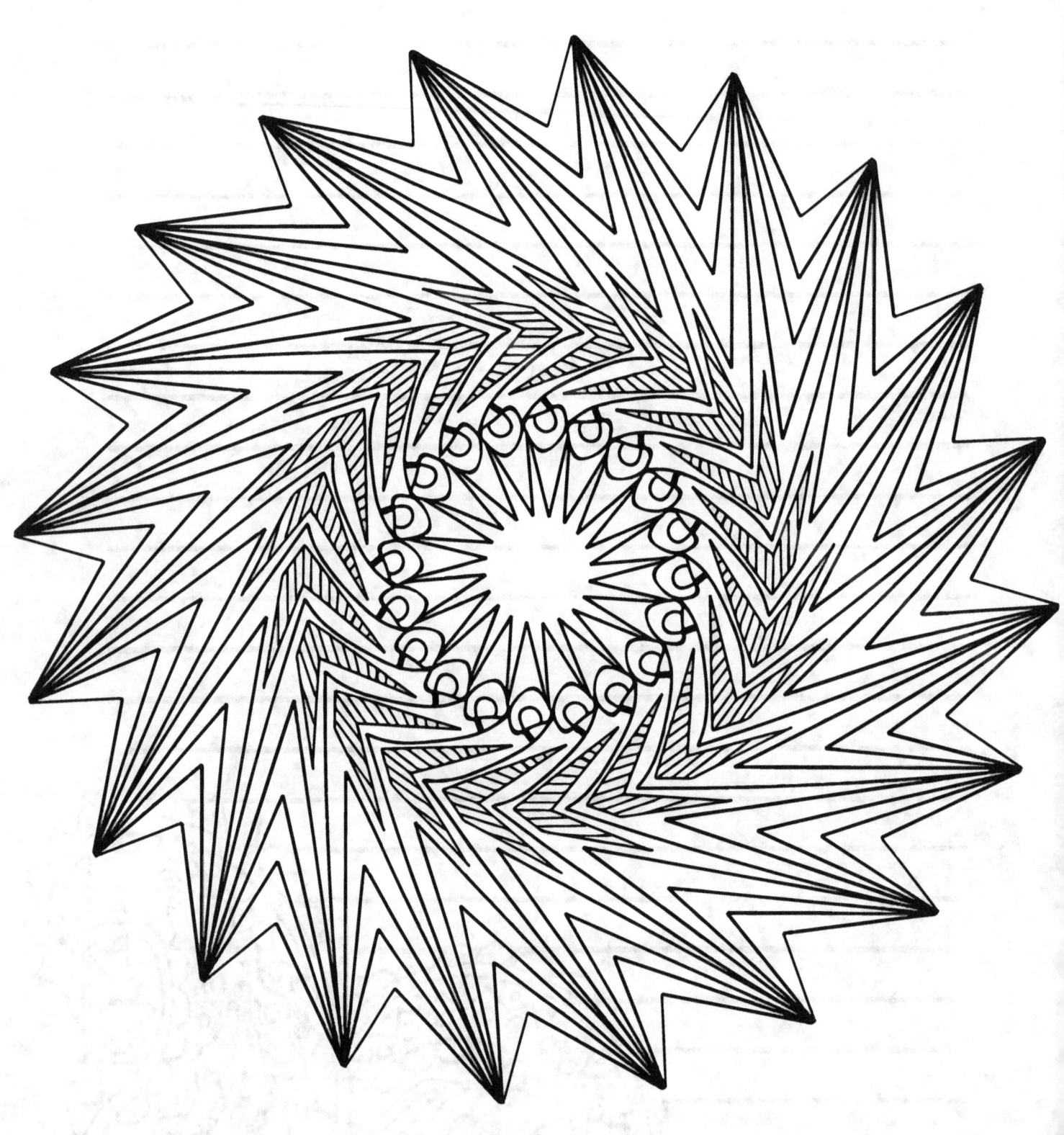

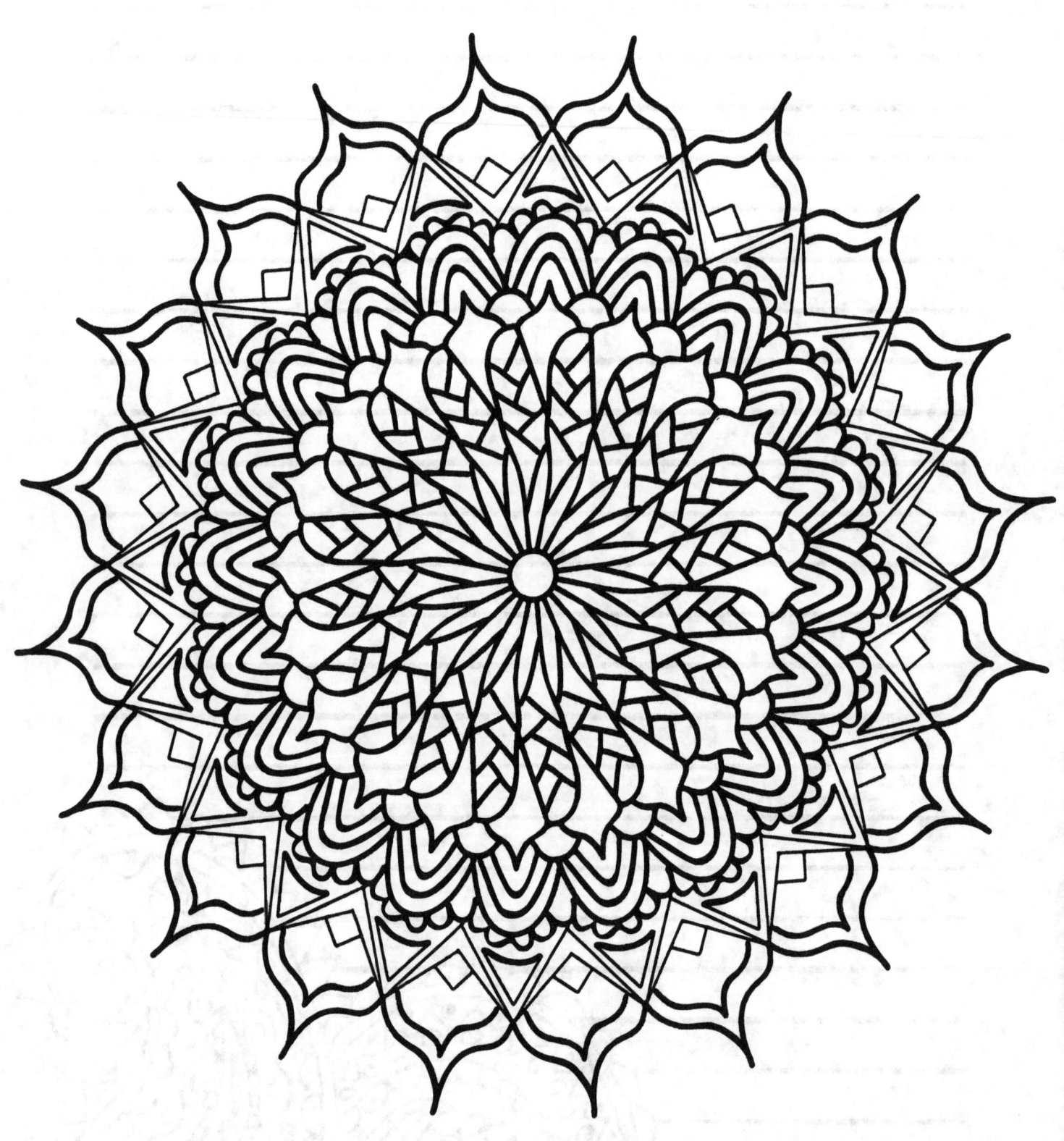

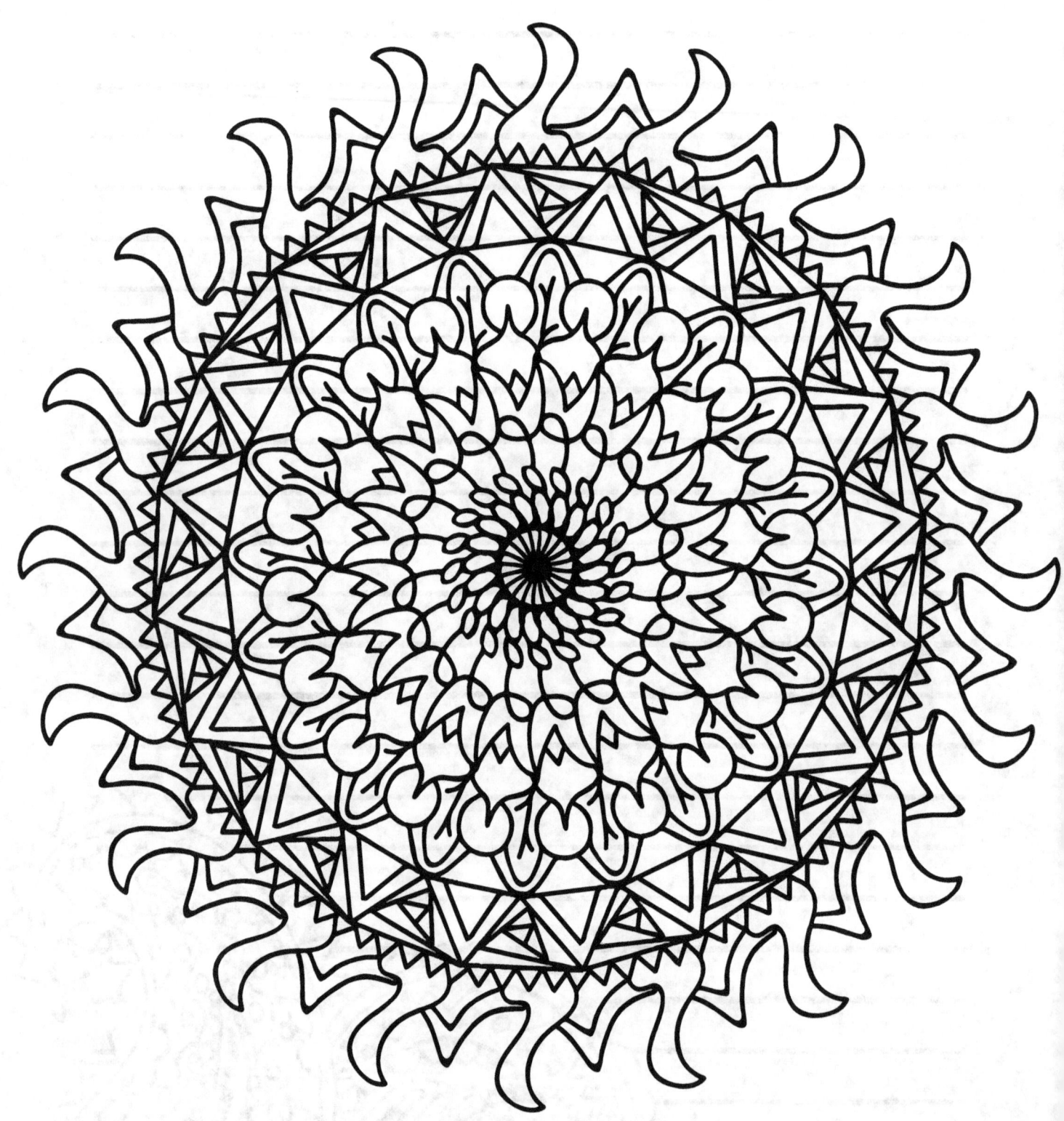

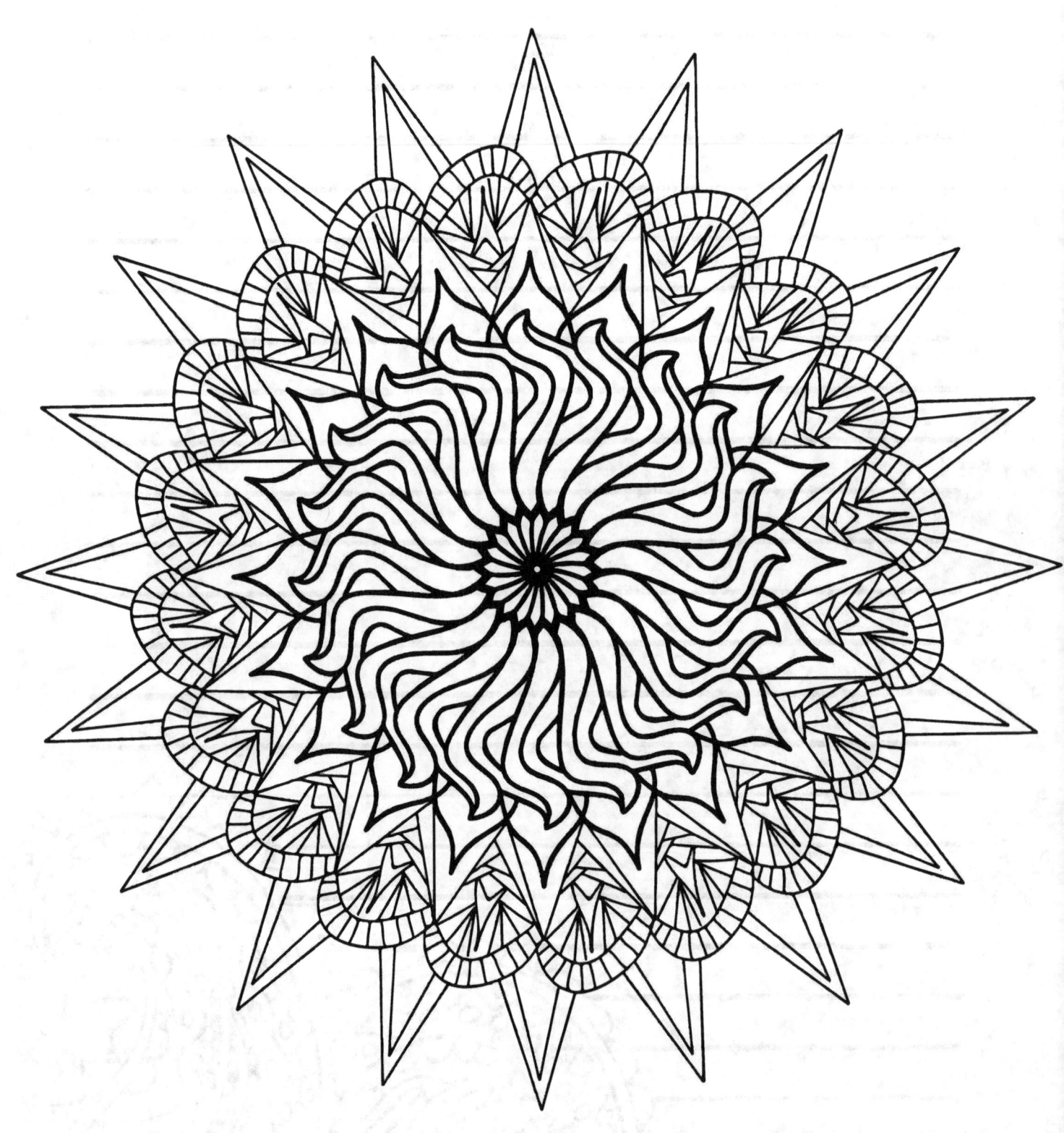

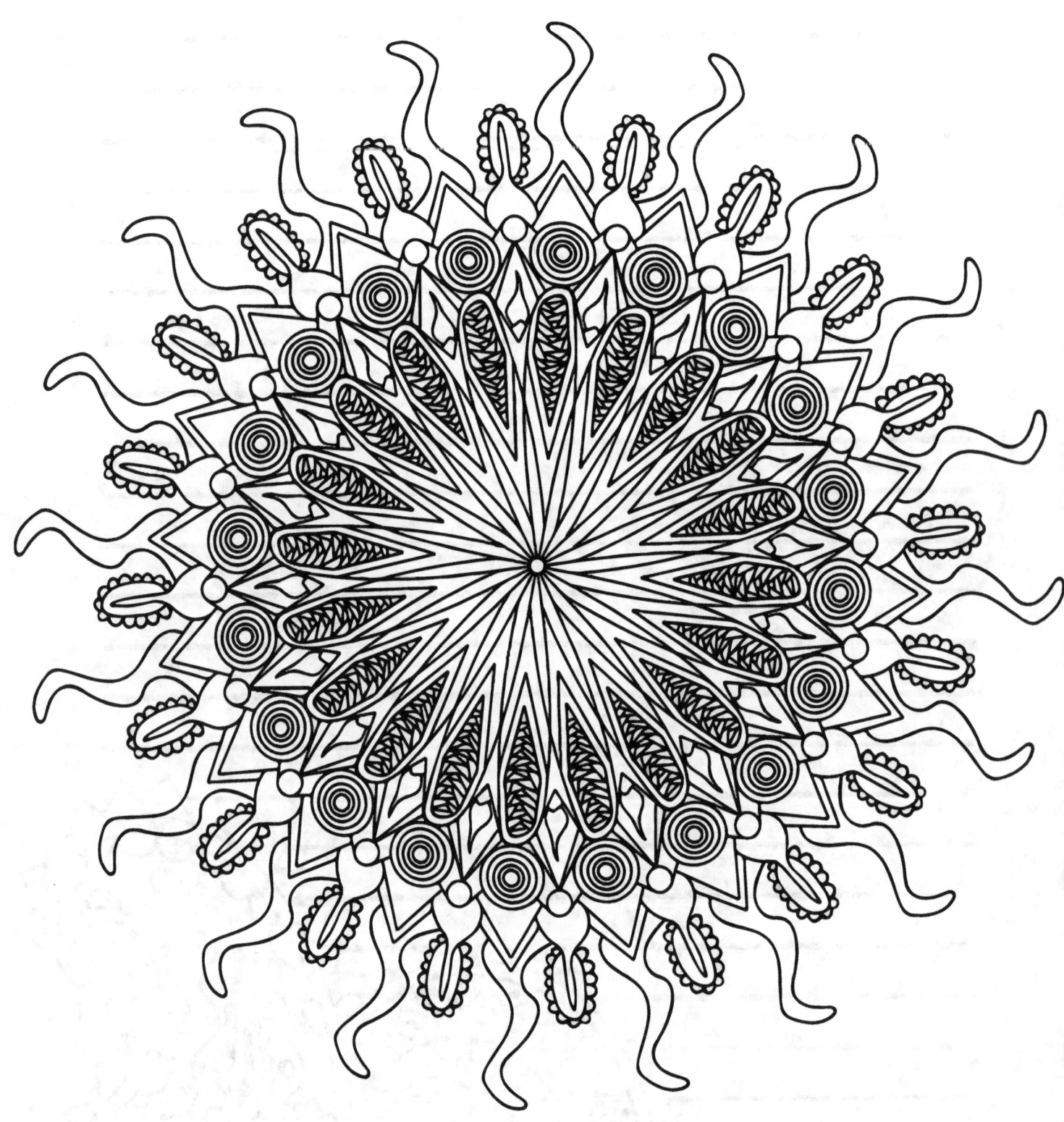

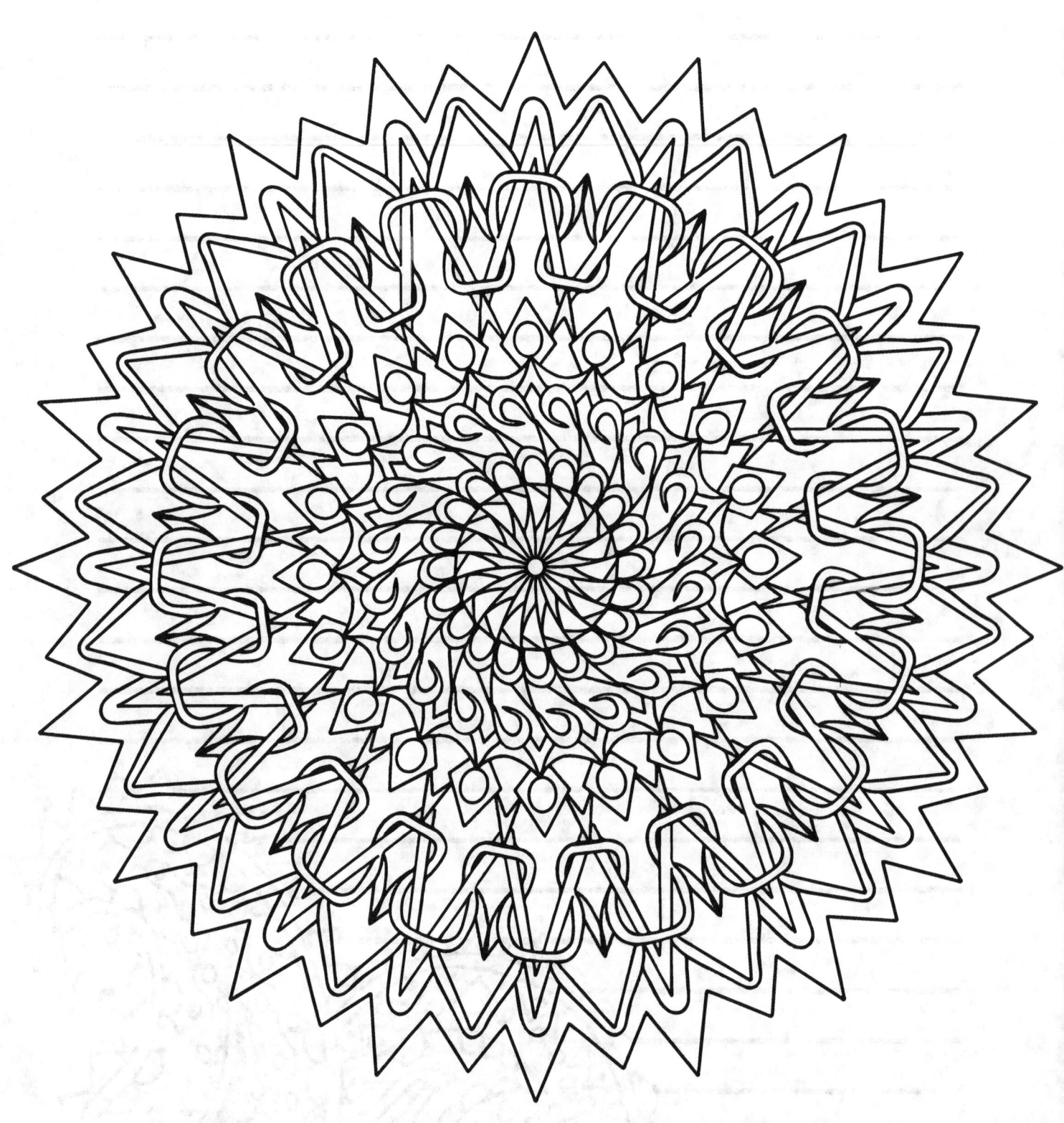

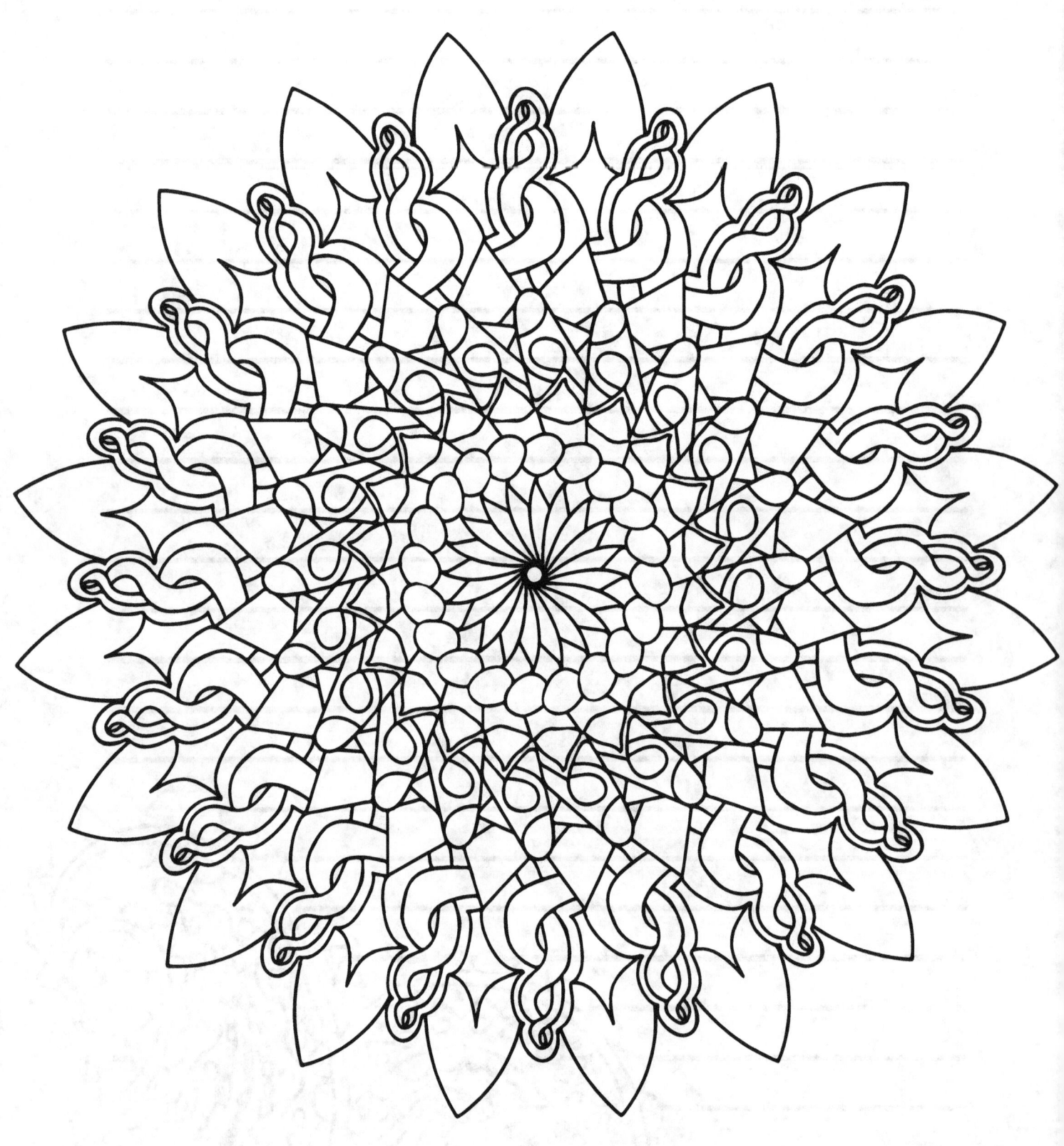

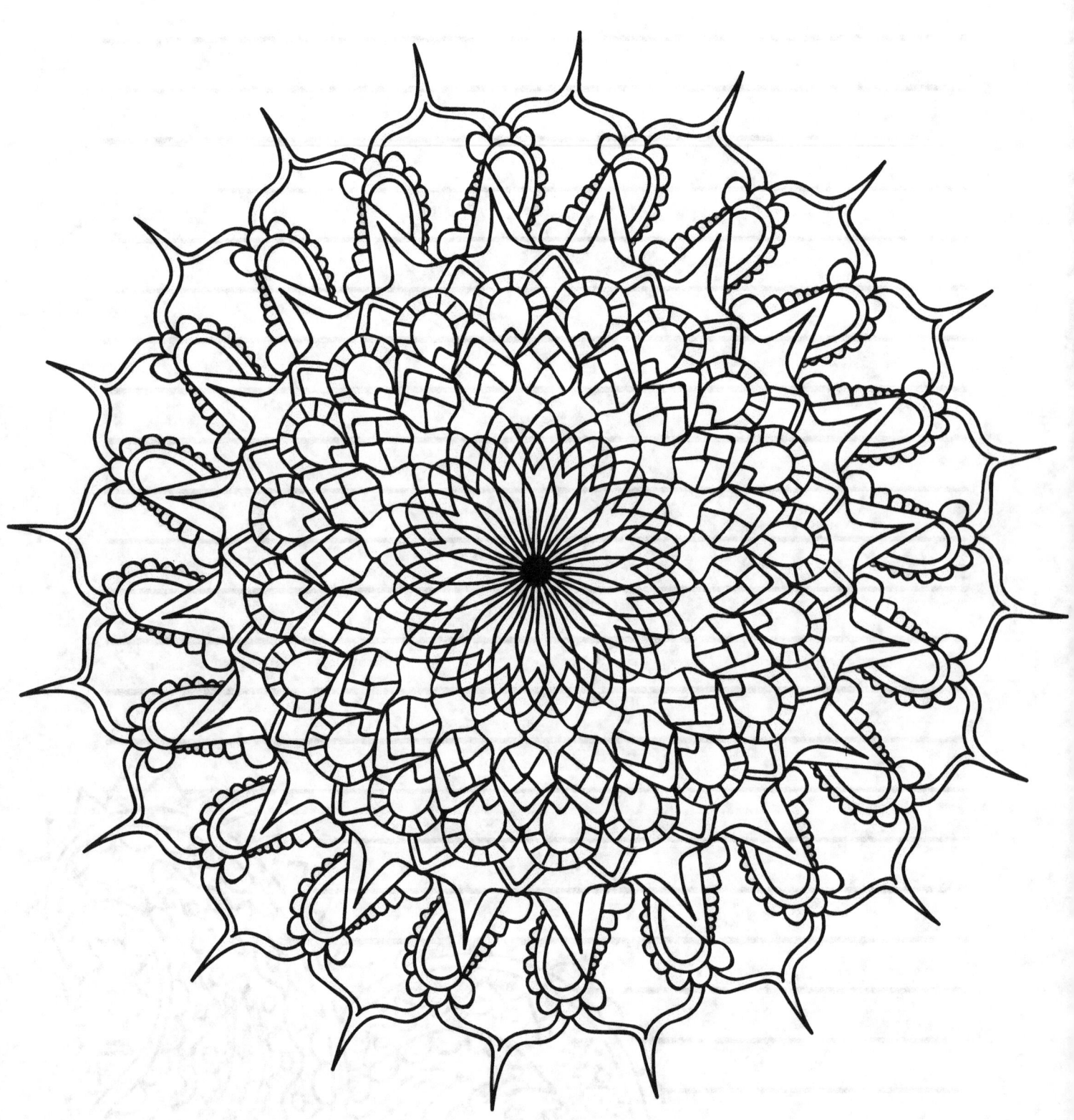

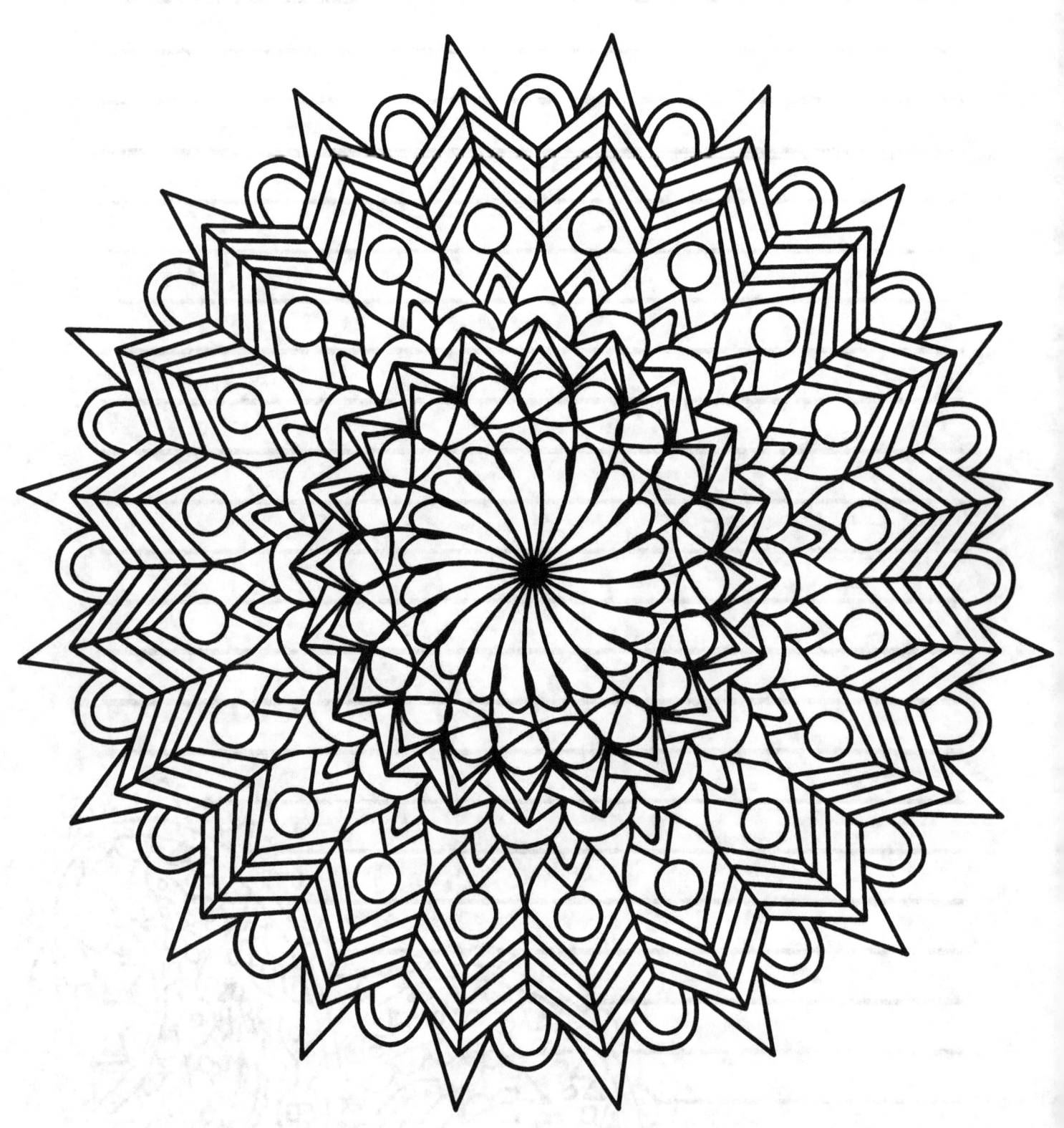

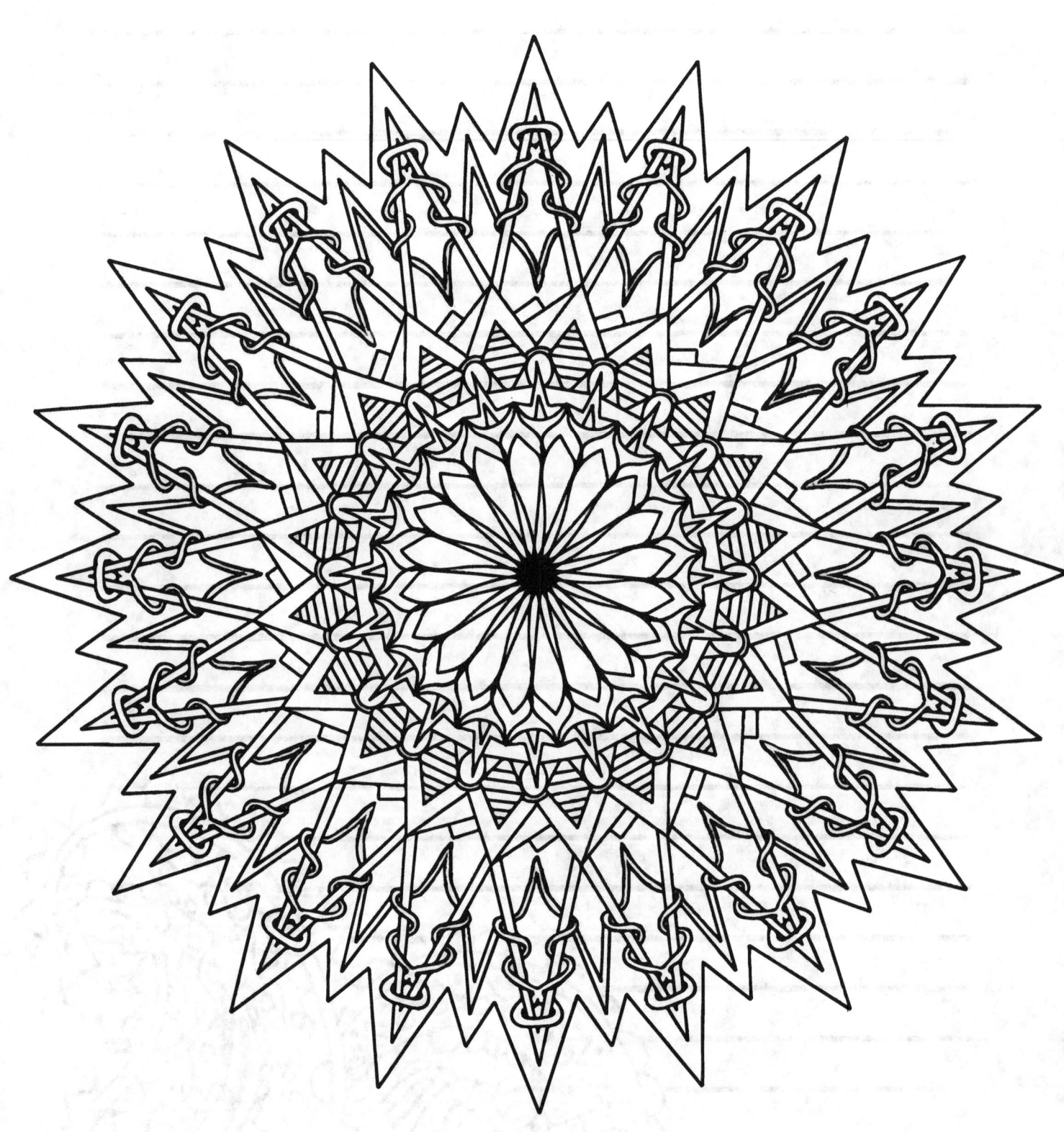

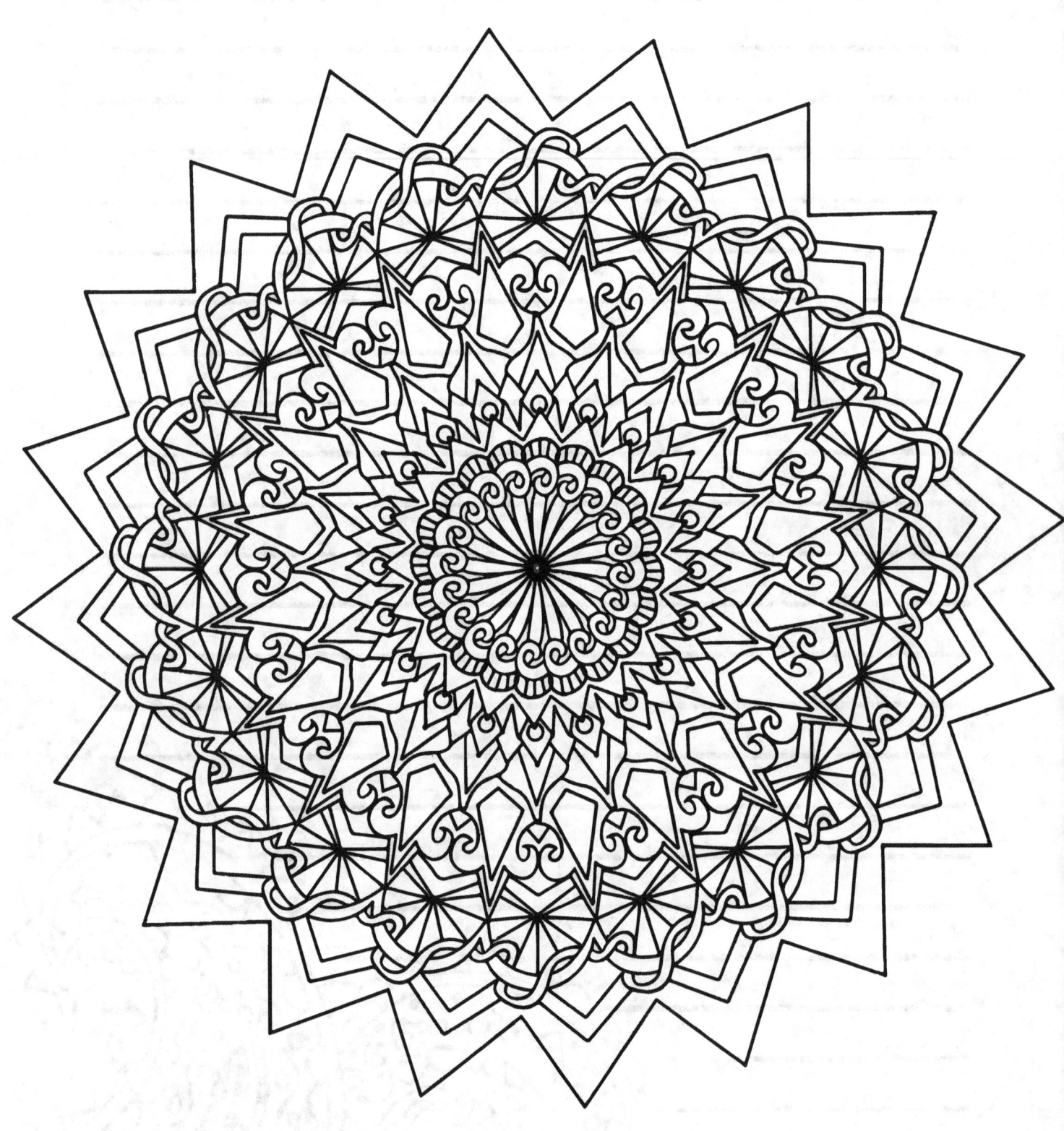

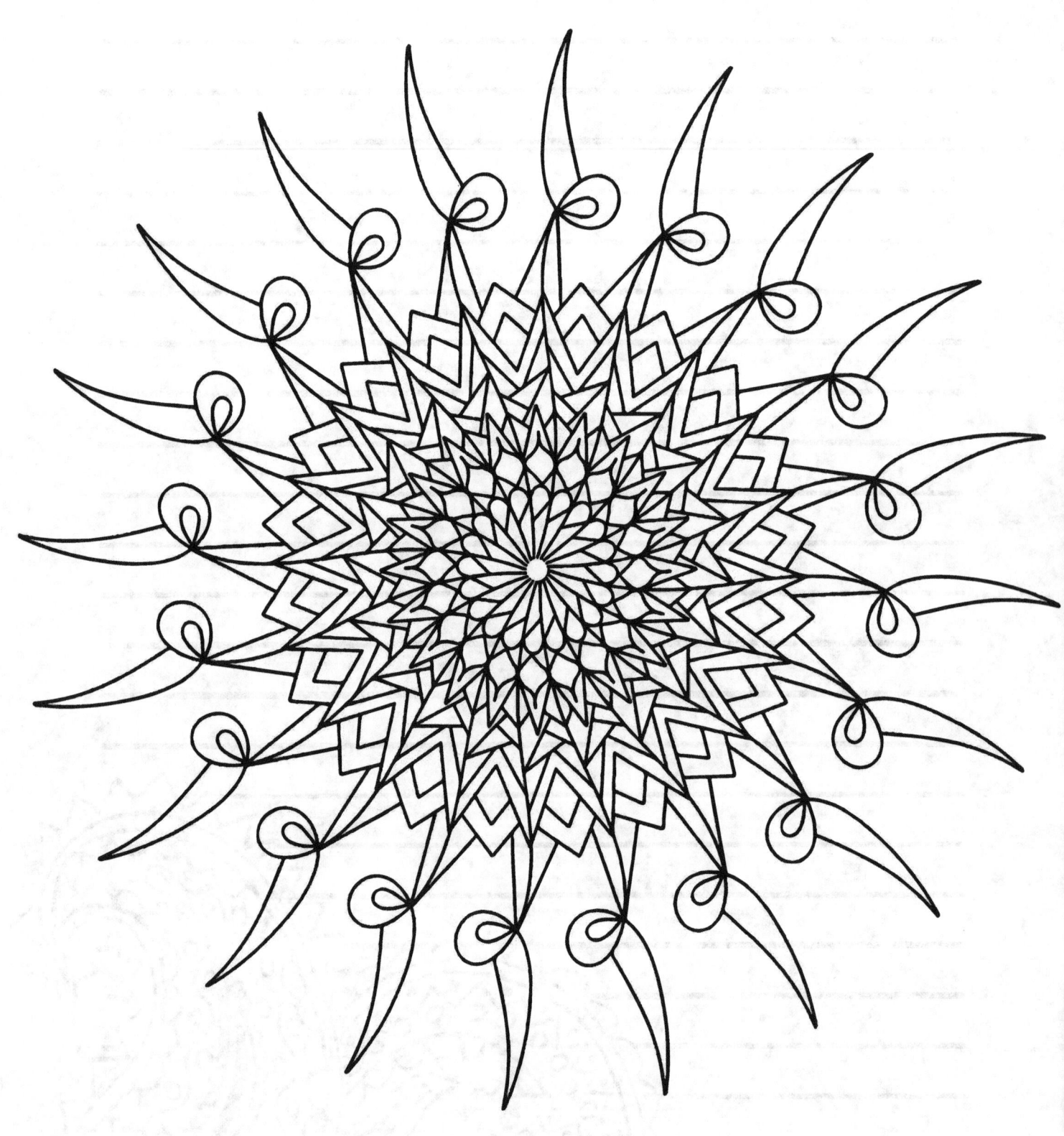

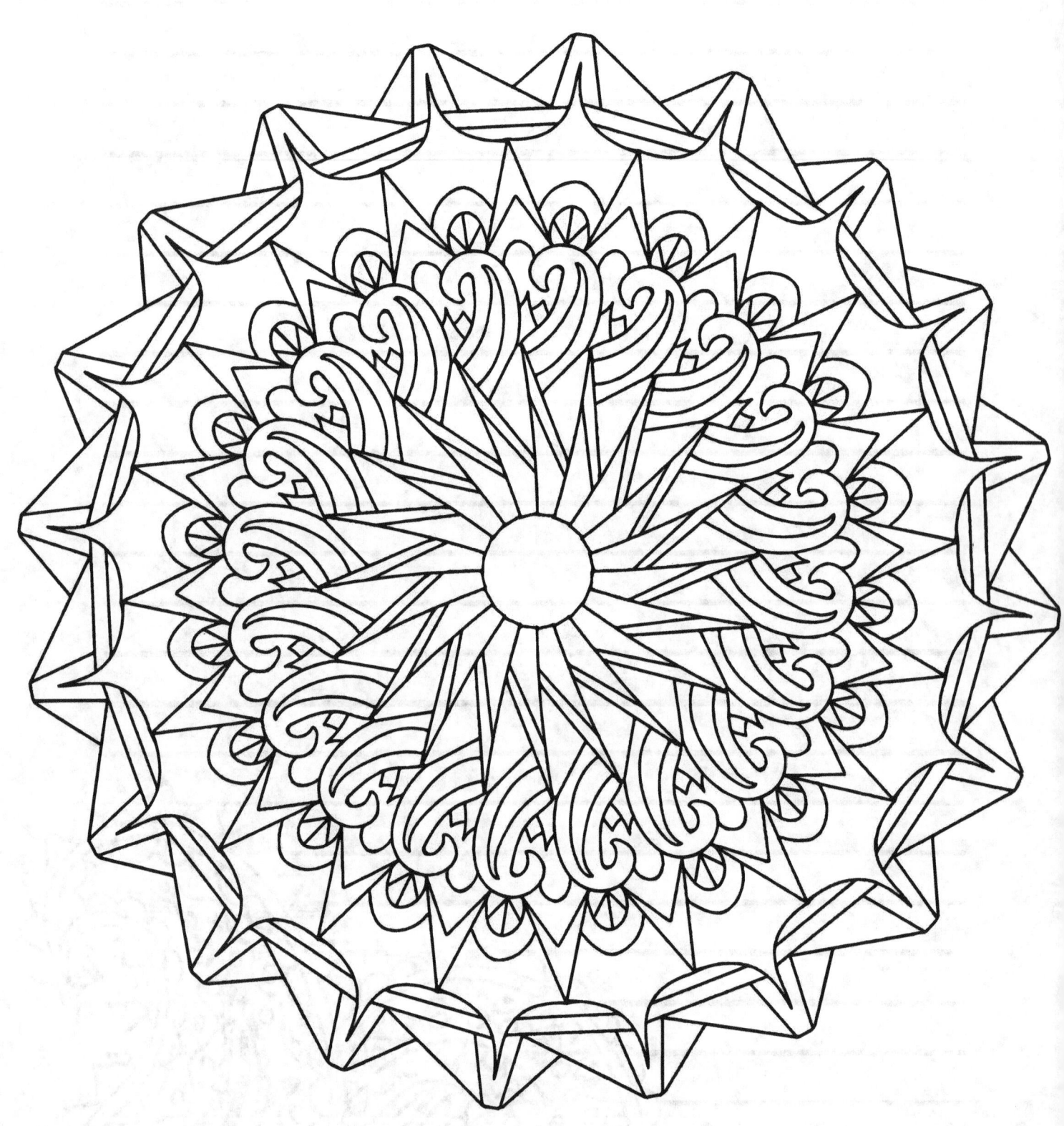

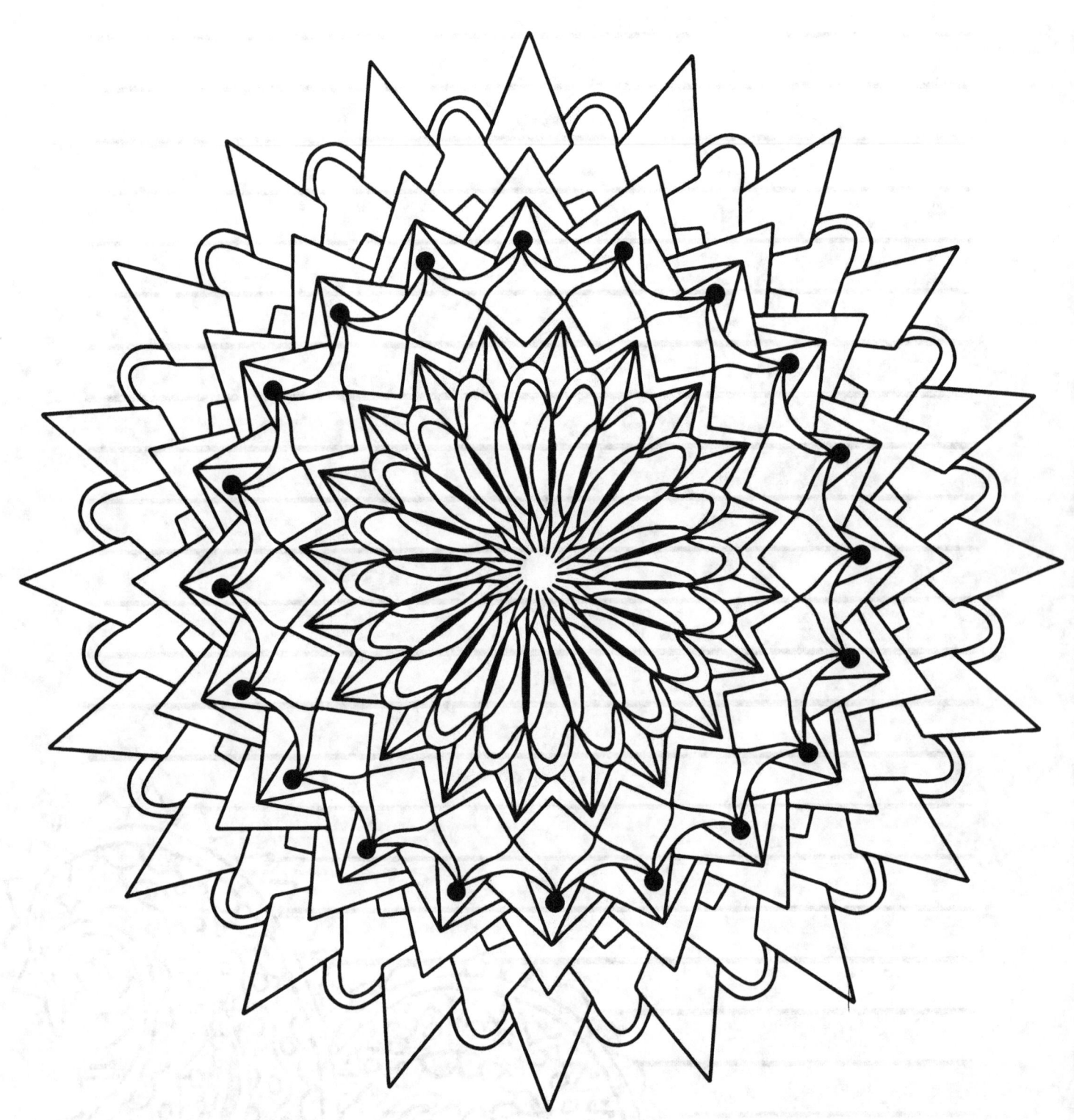

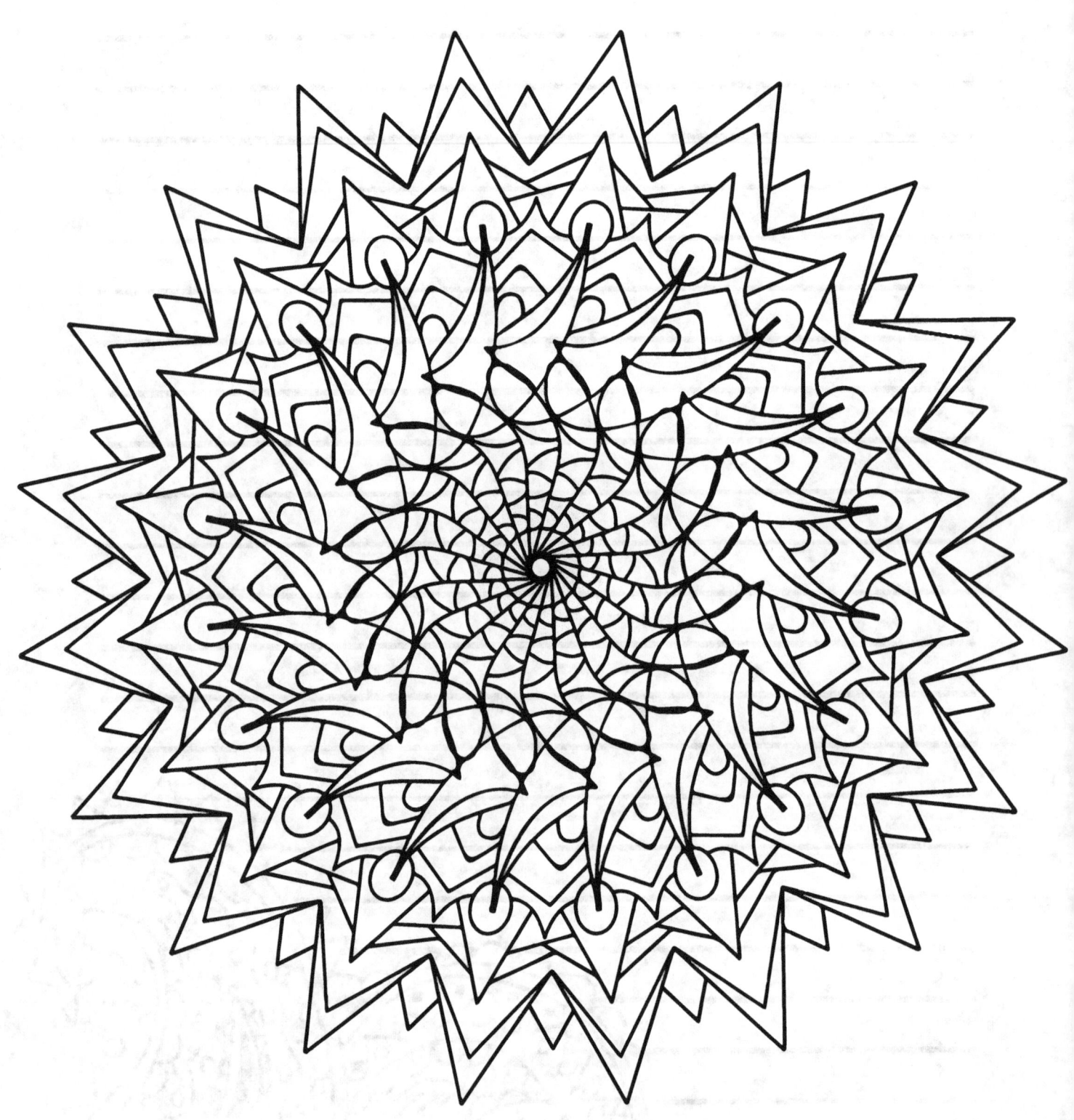

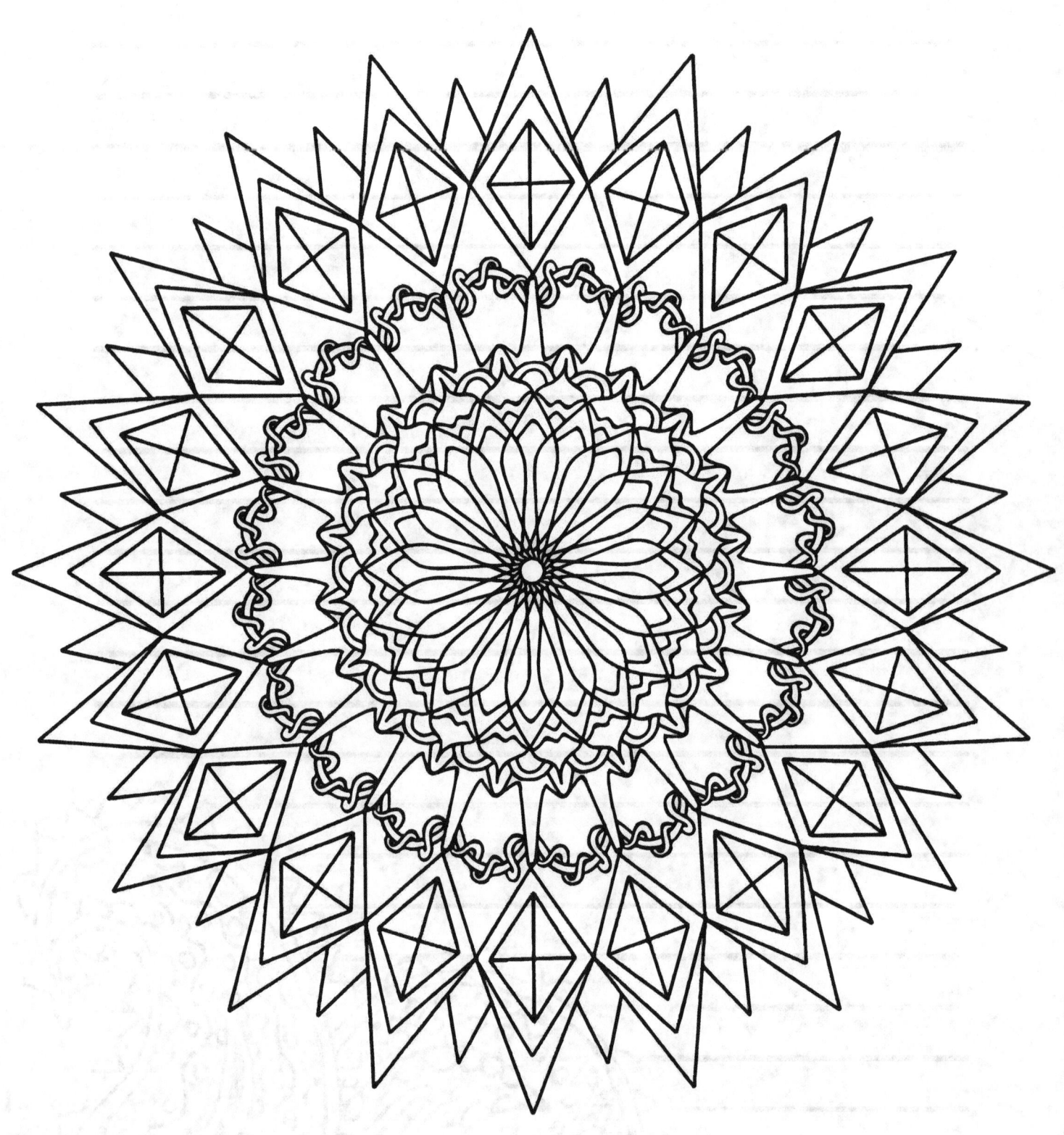

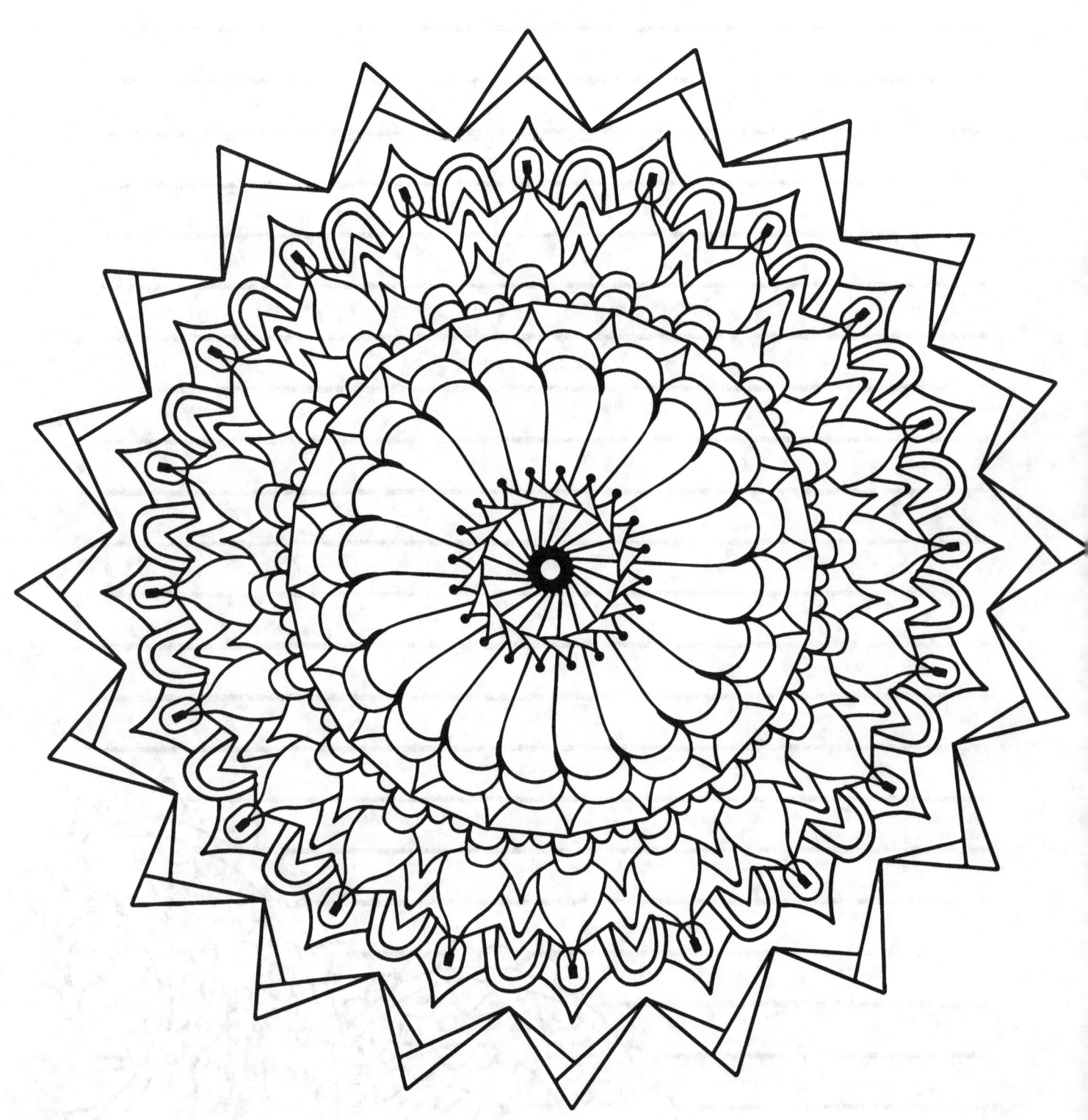

www.ingramcontent.com/pod-product-compliance
Lightning Source LLC
Chambersburg PA
CBHW081159180526
45170CB00006B/2151